CHARACTER DESIGN QUARTERLY

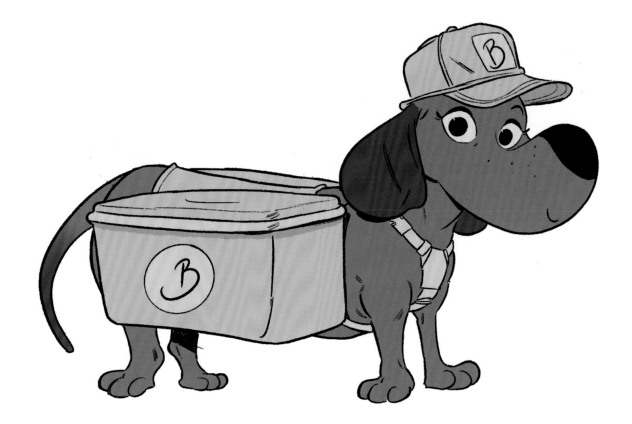

Image © Jordi Lafebre

CONTENTS

WELCOME TO CHARACTER DESIGN QUARTERLY 18

When I was asked to write this issue's editorial in Samantha's absence, I said sure, no problem – *CDQ 18* is bursting with brilliant features to talk about, I won't be able to stop!

For starters, there's Max Ulichney's wonderfully atmospheric cover art. As well as taking us through how he created the image and the inspiring message behind the design, we caught up with Max to find out about changing careers and working with big studios, like Netflix.

And then there's our tutorials – Jordi Lafebre is given two random words and creates a hot dog vendor with both bark and bite, Margana takes us through a stunning redesign of Mother Nature, and we join Bertrand Todesco on a time travelling trip to the Wild West.

We've also got some spectacular art in the gallery this month, a fascinating interview with the founders of the ground-breaking artist's collective Panimation, and loads more great features and tutorials. In fact, there's so much to discover that I've run out of space already, so turn the page and dig in!

SAM DRAPER
EDITOR

Image © Marta Garciá Navarro

BEHIND THE COVER ART:
MAX ULICHNEY

This issue's cover was designed by Max Ulichney, an illustrator and director based in Los Angeles. Over the next few pages he tells us how he made the switch to character design, talks about the importance of pushing your limits, and shares with us some of his work, from kickboxing trombonists to undercover assassins, and everything in between! Max also takes us step by step through how he crafted this issue's beautiful cover, using the pandemic as inspiration for a warm and charming expression of human connection.

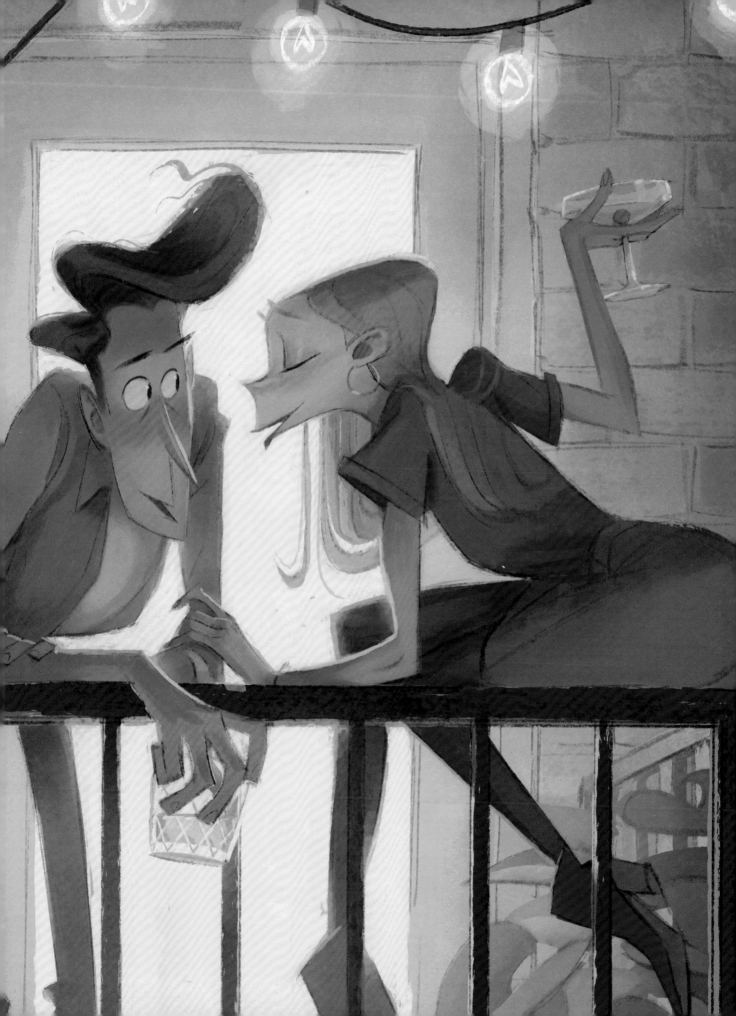

Hi Max, it's a treat having you produce a cover for this issue. For those who might not know you, could you tell us a little about yourself?

Of course! It's an honor to have the chance to paint the cover for a magazine I love so much. As a character designer at heart, this is such an important publication for me. Professionally, I was a commercial CG artist and art director until last year, when I made the switch to animation character design and focusing on my MaxPacks Brushes for Procreate. After 15 years in another industry, it's been great to start a new chapter of my career, exploring and challenging myself in new ways.

Have you worked on any really exciting projects recently?

Last year I had the opportunity to work with Netflix on my first film as a character designer. Collaborating with directors I admire was an awesome experience. There was a perfect combination of being trusted creatively and being pushed out of my comfort zone, leading me to develop characters unlike anything I had designed before.

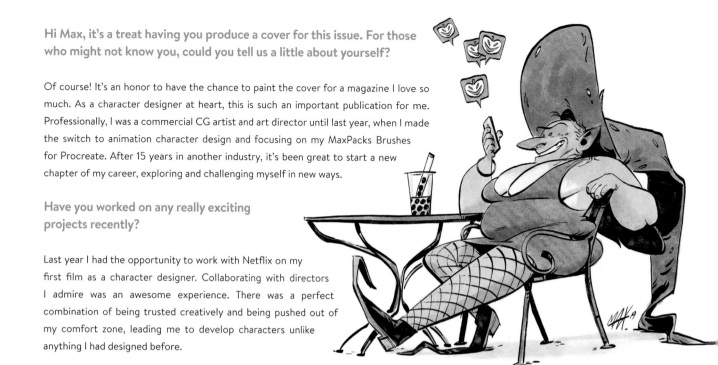

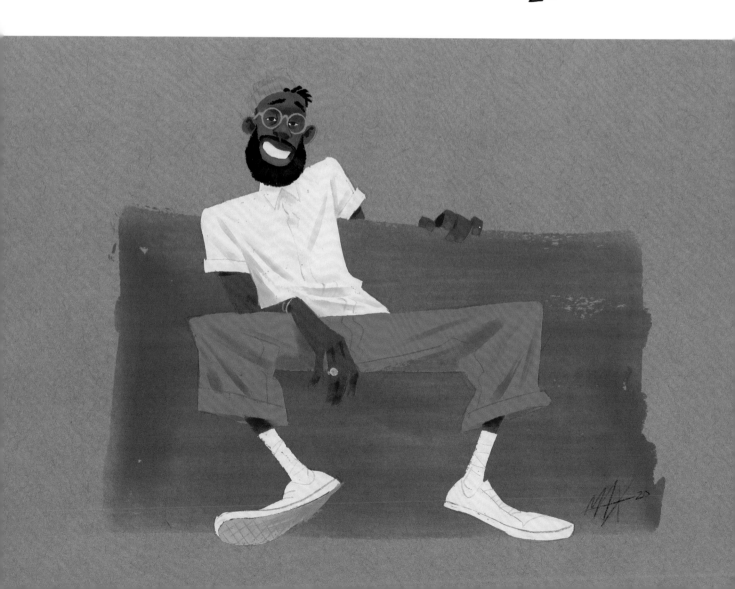

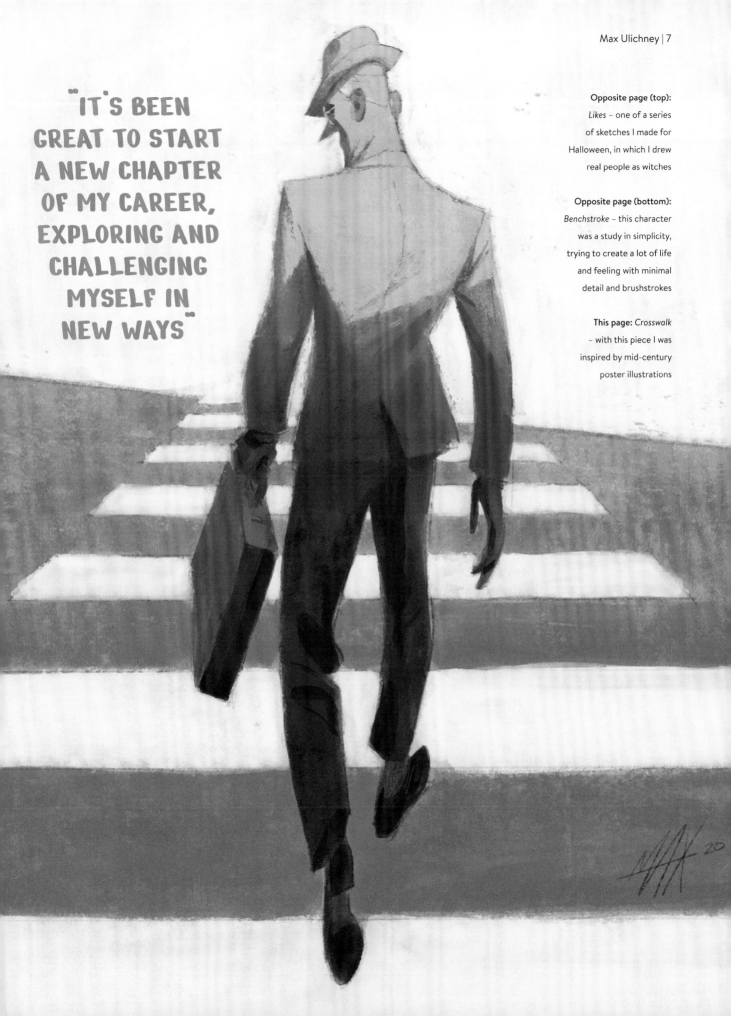

"IT'S BEEN GREAT TO START A NEW CHAPTER OF MY CAREER, EXPLORING AND CHALLENGING MYSELF IN NEW WAYS"

Opposite page (top):
Likes – one of a series of sketches I made for Halloween, in which I drew real people as witches

Opposite page (bottom):
Benchstroke – this character was a study in simplicity, trying to create a lot of life and feeling with minimal detail and brushstrokes

This page: *Crosswalk* – with this piece I was inspired by mid-century poster illustrations

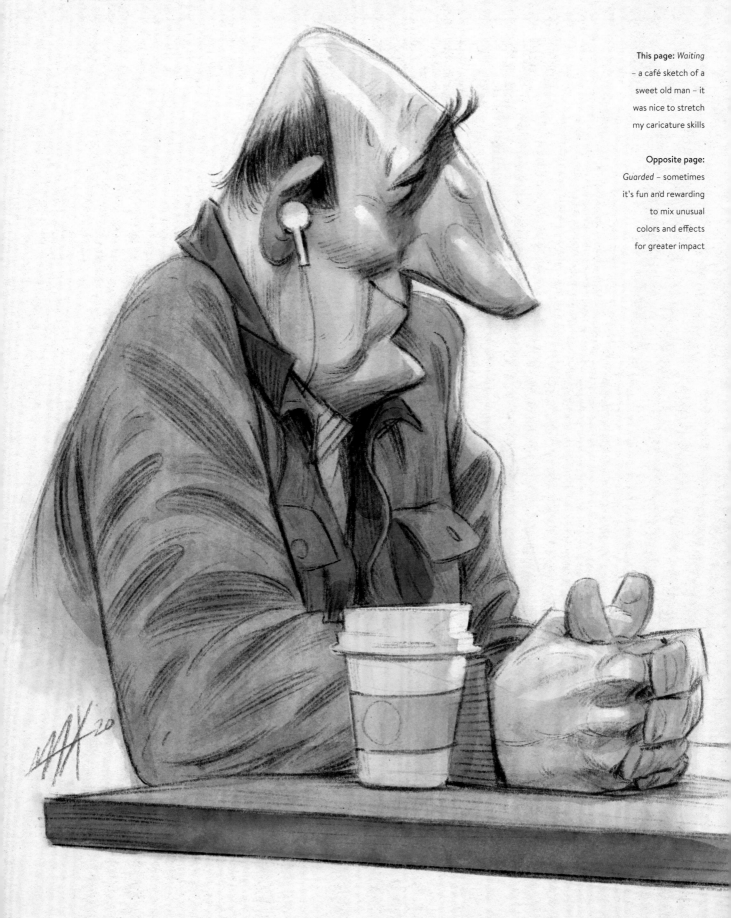

"I THRIVE ON NEW CHALLENGES AND OPPORTUNITIES"

What would you say keeps you motivated to keep creating?

I'm my own harshest critic! I thrive on new challenges and opportunities to push the limits of my skills. There's an element of chasing personal growth that drives me from a technical point of view. And from a creative perspective, of course, I love telling stories and making people smile. When I was in school I would draw cartoons on my lunch bags for friends, and in many ways I feel like I'm still that kid today, just with better tools and a larger audience.

Do you have any advice for someone who wants to break into the industry?

First and foremost, it's never too late! I spent 15 years working in commercials and was worried I was getting too old to change career and progress in a new industry. However, I made the jump at 38 and found that I was only stronger for the experience and insight I brought from my previous job.

I would recommend developing a recognizable and distinctive core style, while still showing flexibility and range within your work. Many people will advise you to create a consistent brand on social media, but I've found that what's good for followers isn't necessarily good for the artist. Different jobs will require distinct styles and inflexible artists may have a hard time adapting or finding work. You should always cultivate and celebrate your versatility as an artist.

CRAFTING THE COVER:
CAPTURING A MOMENT

Thanks to the pandemic, human connection is sorely lacking in so many people's lives right now. The image I created for the cover was inspired by daydreaming of better times to come, when we can share a close moment with one another again. In this tutorial we will explore how you can create an emotionally resonant painting that shows warmth and humanity through shape language and rich, inviting light to capture the feeling of hopeful escapism.

The cover was created in Procreate 5X using my Retro MaxPack brush set on the iPad Pro with an Apple Pencil, but these techniques should work with most mainstream digital-painting platforms.

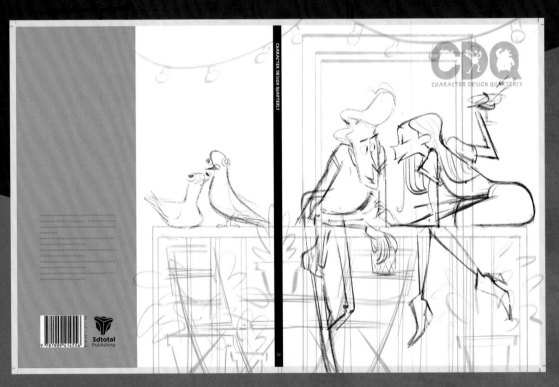

This page: I use the Gesture Sketch Flat brush to draw the finished pencil lines

Opposite page: With the rough design complete I can now sharpen the details and ensure structural elements conform to perspective

DEFINING STRUCTURE

To start I focus on the linework, as this will help achieve a sharp, distinct design language throughout. I like to highlight strong shape choices at this early stage by using bold angles and strong structural designs. Knowing that

I plan to backlight the couple later on, the focus here is on capturing very strong, clear silhouettes. I tilt the characters' main gestural angles toward one another to reinforce the relationship between them. The female character is making the first move, so she

leans in more, while the male's pose is a little less assured, and more surprised.

The idea of the pigeons echoing the main characters' poses didn't occur to me until I considered the layout of the wraparound cover

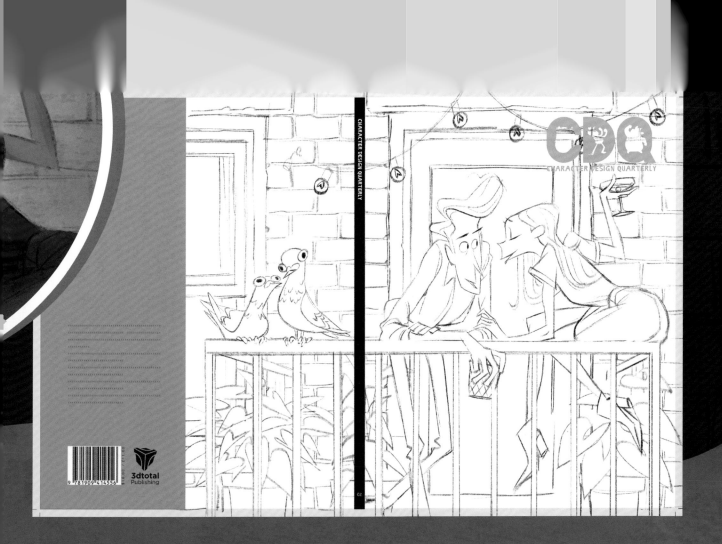

CHARACTER DESIGN QUARTERLY

3dtotal
Publishing

9 781909 414556

02

– the thought of the pose being mirrored by the birds on the back cover made me laugh. Always be open to surprises and allow yourself to explore these ideas, as you never know where they may lead.

ADDING A HUMAN TOUCH

With the rough design complete, I can now sharpen and clarify the details. Procreate's Perspective Guides (Action > Canvas > Drawing Guide) are a huge help for ensuring the railings converge correctly in one point perspective. I use a 2D grid within the same Drawing Guide feature as a reference for the bricks. As I begin to refine the shapes, I can add more subtlety to the anatomy and wrinkles to the clothes, so they don't look too stiff and robotic. This is a piece about human connection, so softening these shapes is key – I don't want the characters to appear too harsh.

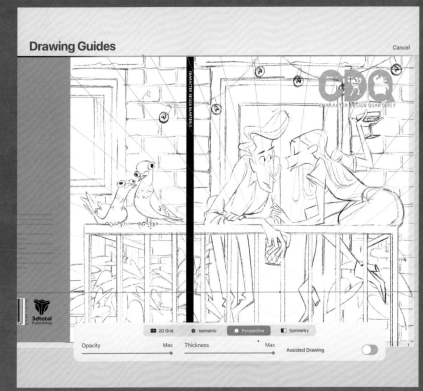

Drawing Guides Cancel

2D Grid Isometric Perspective Symmetry

Opacity Max Thickness Max Assisted Drawing

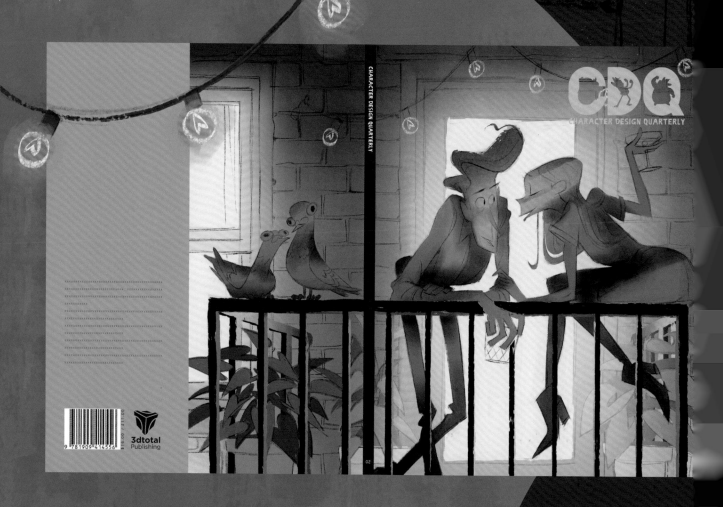

9 781909 414556

3dtotal
Publishing

" TO CREATE
THE HAZY GLOW
EFFECT FROM
THE WINDOWS,
I USE A VERY
SATURATED
ORANGE COLOR
AND SET IT TO A
SCREEN LAYER
BLEND MODE "

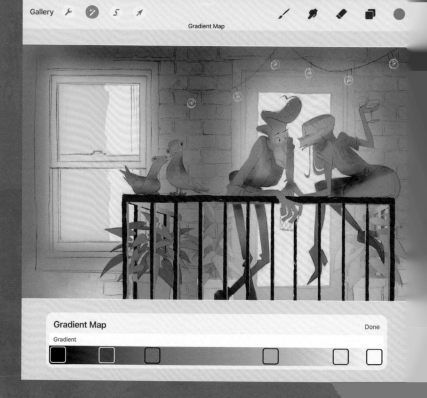

ESTABLISHING VALUES IN GRAYSCALE

It's important to always establish a strong value structure, especially when drawing complex scenes. The composition of this piece is built around framing the couple in the bright window. The dim light will make them appear more intimate and the haze will help their silhouettes read clearly. I group my values and don't put too much contrast in every area, as this can act like camouflage, muddying clear shapes. Squinting or zooming out from the picture can help to make sure things read well. At this stage, I am still keeping things simple – using a large, soft brush like the Gouache Shader Wash, there's no need to paint in all the details yet.

LIGHTING UP THE EVENING

This piece is perfect for the Gradient Map tool (Adjustments > Gradient Map). This is best used on a flattened screen grab initially, to get a simplified look at color relationships more easily. Once I'm happy with the gradient, I apply it to the individual layers on the main piece, adjusting each one individually to find the right balance of warm and cool colors emanating from the moon and street lights below. To create the hazy glow effect from the windows, I use a very saturated orange color and set it to a Screen layer blend mode.

BASE COLORS

I now focus on the local color of the characters and objects – this is the inherent color of an item without the influence of lighting. I start by creating a new layer above the lighting layer and Clipping Mask it to the layer below (Layers > tap layer > Clipping Mask). This ensures the new layer will share the opacity of the layer to which it is clipped. Now I can paint the flat skin tones, hair color, and wardrobe colors. Finally, I set the layer blend mode to Multiply. Reducing the opacity slightly will help if the colors appear too dark.

Opposite page (top): Establishing a strong value structure is easier to do in grayscale

Opposite page (bottom): Establishing the color palette using the Gradient Map tool

This page: The lighting layer (A) and local color layer (B) are combined with a Multiply layer blend (C)

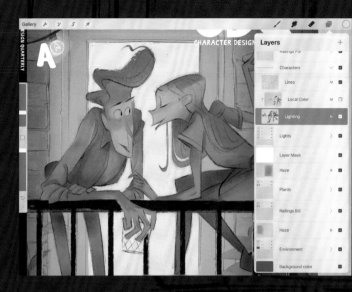

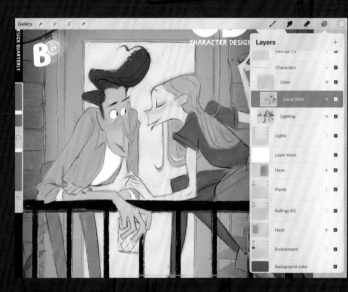

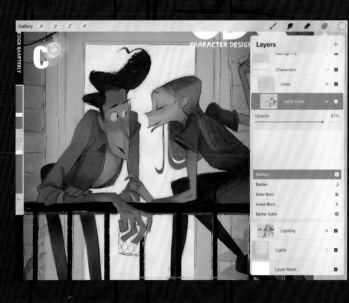

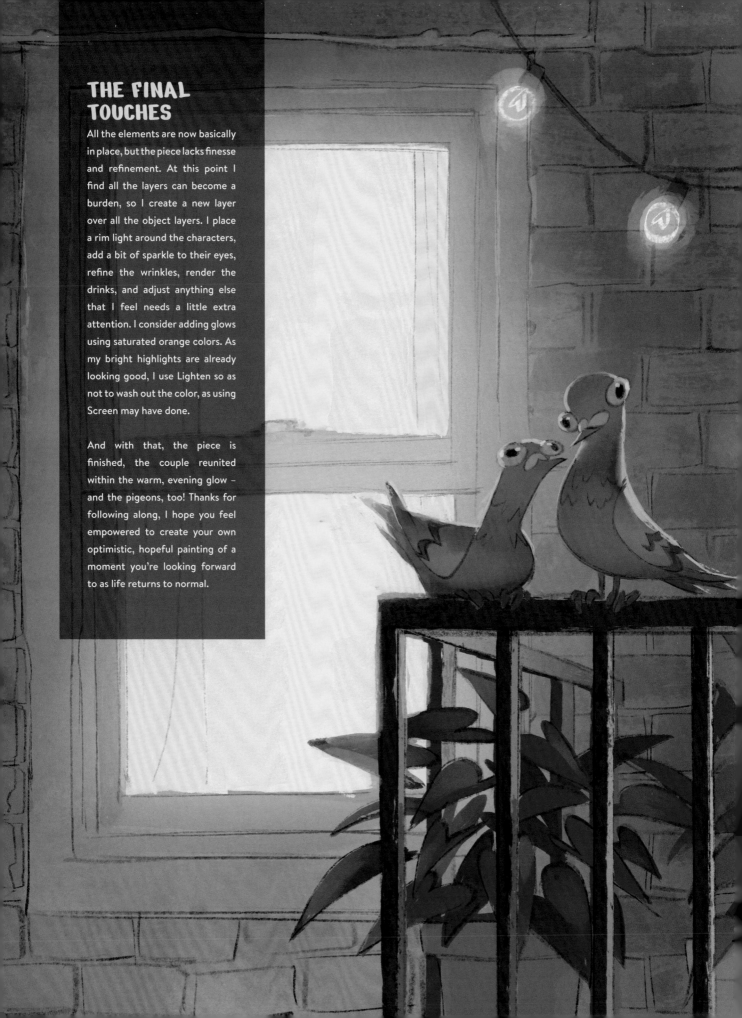

THE FINAL TOUCHES

All the elements are now basically in place, but the piece lacks finesse and refinement. At this point I find all the layers can become a burden, so I create a new layer over all the object layers. I place a rim light around the characters, add a bit of sparkle to their eyes, refine the wrinkles, render the drinks, and adjust anything else that I feel needs a little extra attention. I consider adding glows using saturated orange colors. As my bright highlights are already looking good, I use Lighten so as not to wash out the color, as using Screen may have done.

And with that, the piece is finished, the couple reunited within the warm, evening glow – and the pigeons, too! Thanks for following along, I hope you feel empowered to create your own optimistic, hopeful painting of a moment you're looking forward to as life returns to normal.

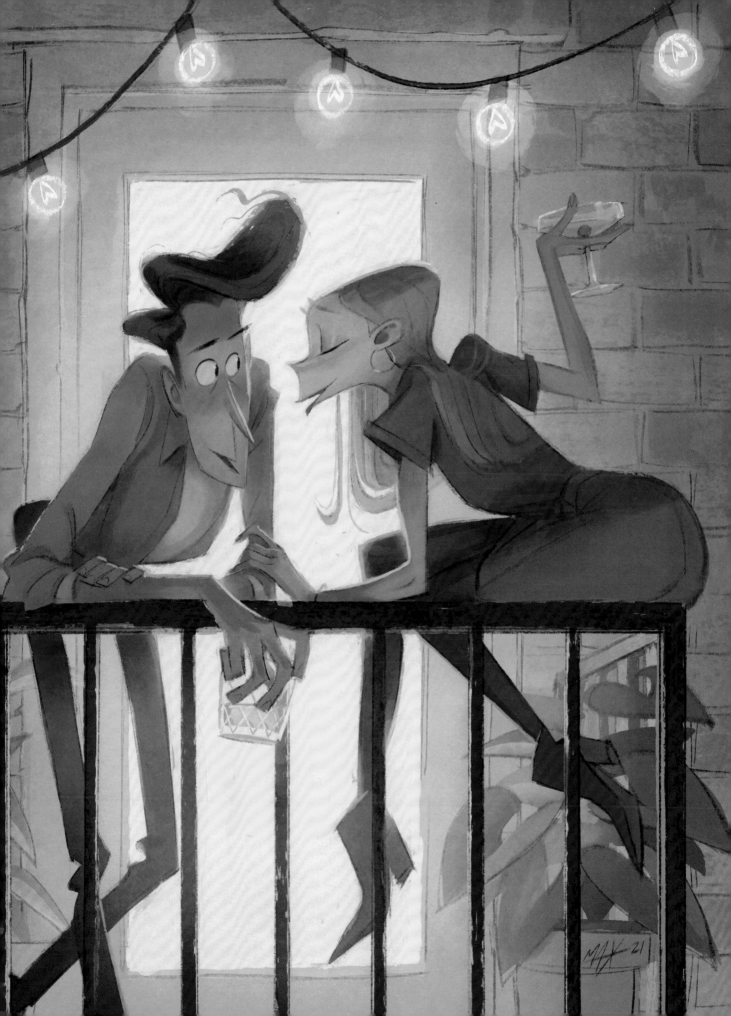

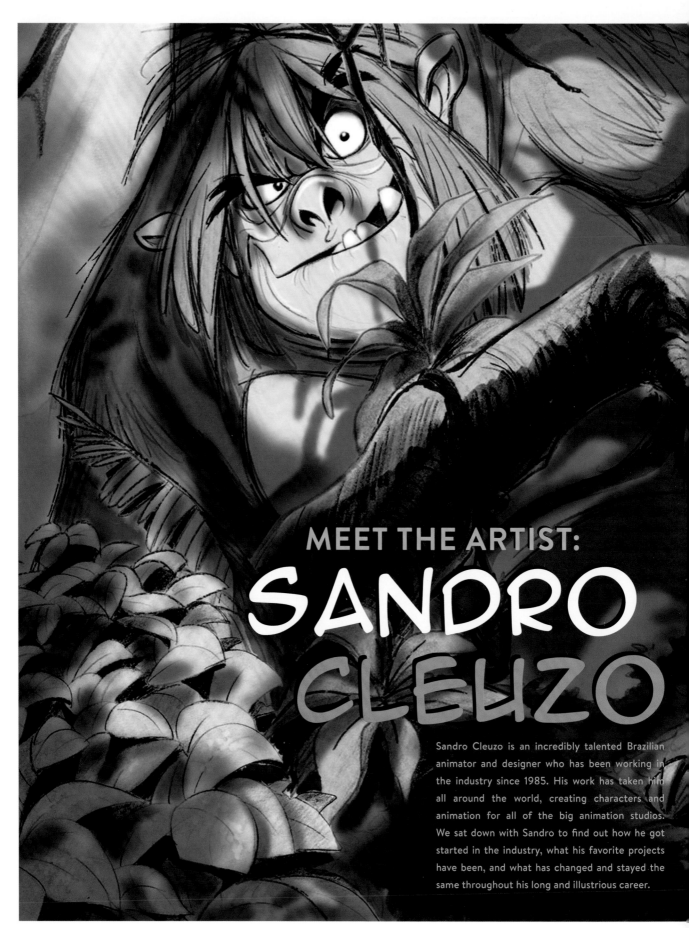

MEET THE ARTIST:
SANDRO
CLEUZO

Sandro Cleuzo is an incredibly talented Brazilian animator and designer who has been working in the industry since 1985. His work has taken him all around the world, creating characters and animation for all of the big animation studios. We sat down with Sandro to find out how he got started in the industry, what his favorite projects have been, and what has changed and stayed the same throughout his long and illustrious career.

Hi Sandro, thanks so much for taking the time to talk to us. Could you tell us a little about yourself and what you do?

I'm a character designer and animator, and I've been working in the industry for 35 years. I started my career at a very young age, back in 1985, when I was hired at one of the most important animation studios in my hometown of Sao Paulo, Brazil – I was 15 years old. The studio produced hand-animated TV commercials and was an amazing place to learn my craft. After four years there I was hired at Don Bluth Studios in Dublin, Ireland, working on animated feature films, which had always been my long-term goal. In 1997 I fulfilled a lifelong dream by moving to Walt Disney Feature Animation and began contributing to the rich legacy of animated Disney features. Today, I work as a freelancer for many studios, as either an animator or character designer. I've worked for Disney, Bluth, Sony, Laika, Warner Brothers, Paramount, and many others.

What first interested you about character design and why did you decide to follow that career path?

I've always loved to draw, since I was very young. My parents told me that as a small child I would ask my aunts and cousins to pose for me! I would draw all sorts of things around the house, like furniture and appliances. I also loved watching animated cartoons. We had a channel in the early 80s that showed all kinds of cartoons from Japan, America, and Europe, so I was so exposed to many different styles from a young age. I used to watch the shows with paper and pencil in hand and would copy the characters, trying to learn how to draw each of them.

At that time I had no idea I would be able to work in animation, nor that there were studios producing shows right there in São Paulo. However, I knew there were comic books published locally, so I started drawing my own. One day at school, I finished a geography test

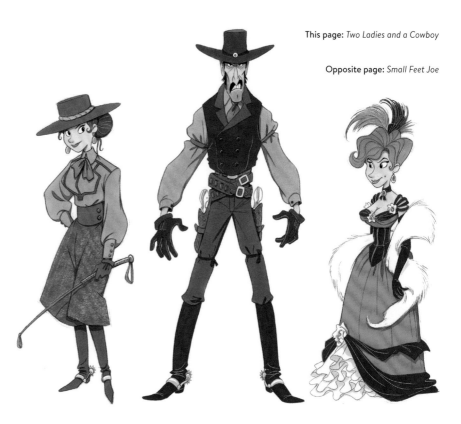

early and, with time to spare, pulled out my pencils and started to draw as I waited for the rest of the class to finish. My teacher saw what I was doing and asked if she could borrow the books I'd finished so far. I excitedly agreed, but didn't ask why she would want them – only later did I realize she had sent them to the biggest and most famous comic-book studio in Brazil, Mauricio De Sousa! De Sousa created the most popular comic-book characters in Brazil, many of which are still popular today. They liked my comics and offered me an internship there. I was only 14 years old and would go to the studio every day after school.

The switch from comics to animation happened by chance. While on my internship at the comic-book studio, I met a lady who was an animator for the same company – their animation department was in a separate building, so I had no idea they even existed. I showed some interest and so she took me to visit their studio and the whole experience was magical. It was the first time I saw the equipment that animators used and how their desks were different. I remember, she grabbed

a stack of paper from her desk and started flipping through the pages – on each page a character was posed slightly differently and, as the pages flashed passed my eyes, the drawing came to life. Right then and there I knew this was what I wanted to do – the animation bug had bitten me!

When I returned to my desk at the comic-book studio, the supervisor called me into the office. She had heard that I had visited the animation department and wanted to work there, so she fired me on the spot! She was so mad that I wanted to switch to animation. I was surprised how badly she reacted and felt devastated for being kicked out – I felt like I had let my parents and teachers down. Little did I know it was the best thing that could have happened to me. I found the perfect job at one of the most prestigious animation studios at the time, Briquet Films, and there I began to really learn my craft. Without leaving the comic-book studio, I may never have had the chance to work there, so everything turned out for the best in the end!

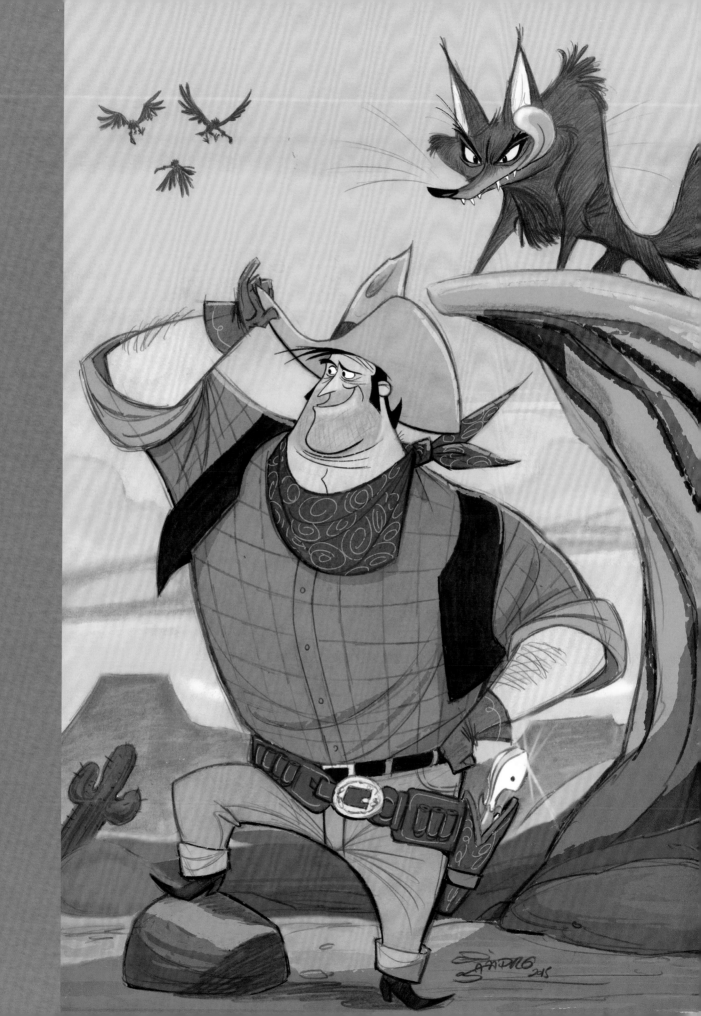

You have worked in this industry for a while. How has the industry changed since you started your career?

To be honest, it has changed quite a lot. When I started in the mid 80s, we produced all our work by hand, no computers at all. All the animation was done on paper and transferred to acetate cels, painted by hand and then shot on camera with film. When I moved to Don Bluth Studios and worked on feature films, we were still using the acetate to paint the artwork and were still shooting on film, but we were starting to add some computer backgrounds here and there. This was the early 90s and computer animation was still very primitive at the time – any complex backgrounds were painted traditionally on paper with acrylic paint.

Back then, we'd also have a traditional, physical portfolio, usually black leather bound, where we kept our best work. When we were applying for positions, we would physically ship the portfolio to the studios and were forever afraid of it getting lost in transit! These days, artists have their work online and some are even hired on the strength of their work posted on Instagram or Facebook.

Another major difference is that nowadays you can basically create your own animation project from home, with a computer, a digital tablet, and a few programs. When I started it was simply impossible to do it all by yourself.

As much as the technology has changed, the creative challenges are still very similar. We are still drawing characters on paper or digitally, and when animating them we are still thinking about the acting and storytelling in the same ways.

This spread: *The Visit*

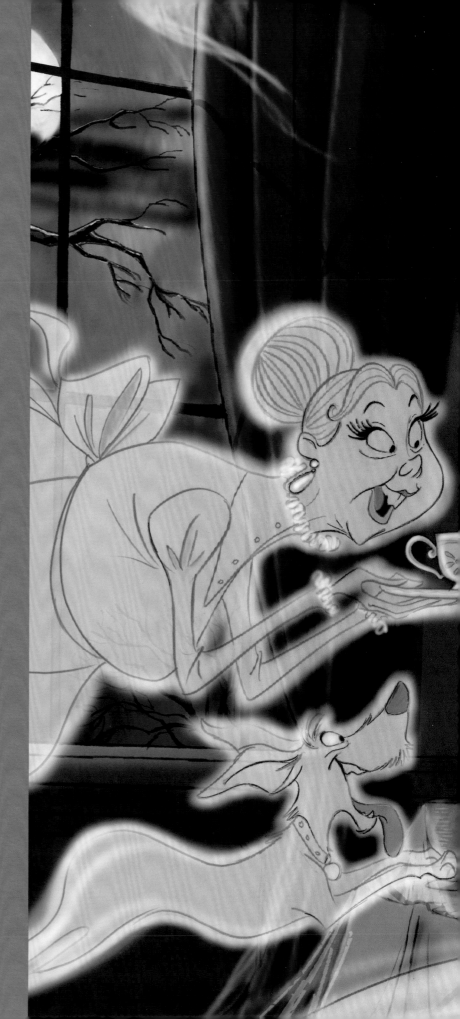

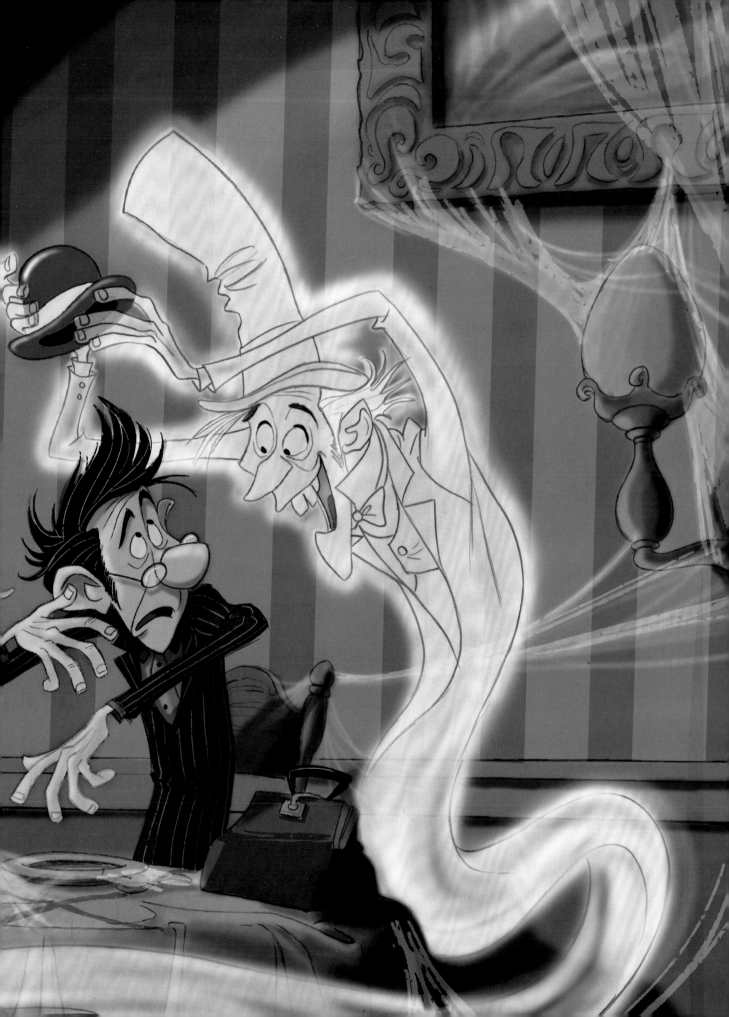

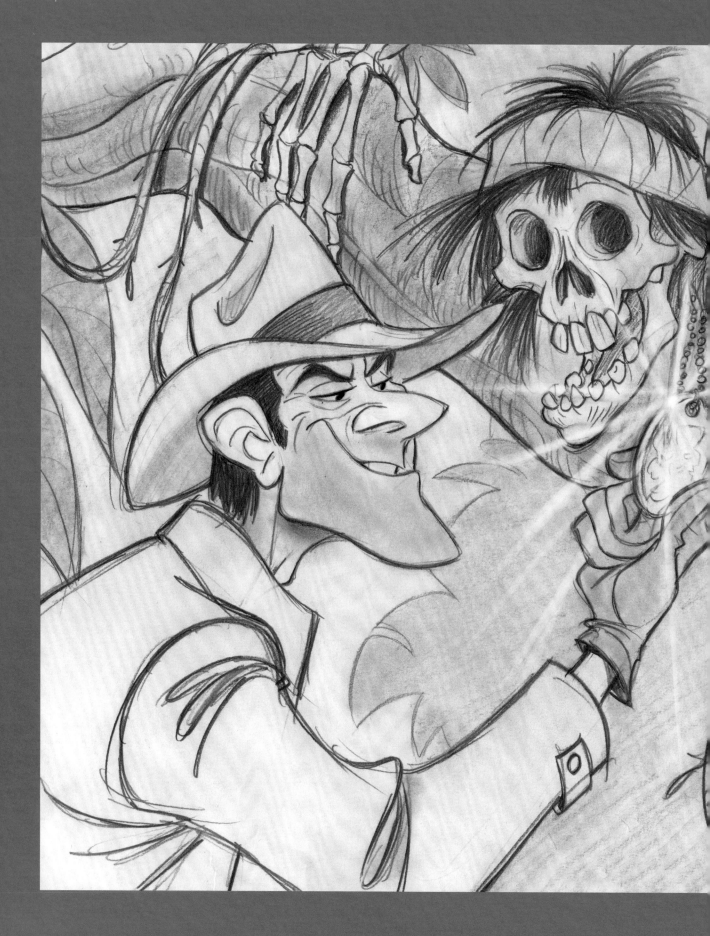

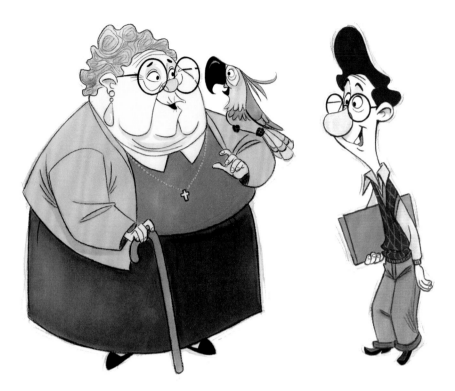

Besides Disney, what are the other notable studios you've worked with, and have you noticed a difference between how they operate?

I've also worked for Laika, Sony, Paramount, Dreamworks, and Warner Brothers. Each studio has its own culture and way of doing things, but it doesn't really change the way I work – I'm still drawing or animating, and I approach it in the same way. I also love to change styles, and working for various studios allows me to do that.

What is your process when working on an animated sequence for a movie – the penguins in Mary Poppins Returns for example?

On *Mary Poppins Returns* I was an animator only. We did it all on paper, the way we used to do it,

and I approached the project the same way I always have. I would be issued a shot and would talk with the animation director to understand what the scene was about and what specifically they were looking for. Next, I listened to the soundtrack and started planning the animation by doing some small thumbnails. When I had something I thought worked, I started doing the actual animation drawings. I would do the main key drawings in rough and do a pencil test to show the director and get their feedback. With their approval, I would then do a second pass where I brought the drawings on-model, adding all the final details, and then do a new test and get approval again before moving on to the next shot. A shot with all four penguins in would take a couple of weeks to do.

Opposite page: A character for a personal project in the style of Indiana Jones

This page: *Grandma*

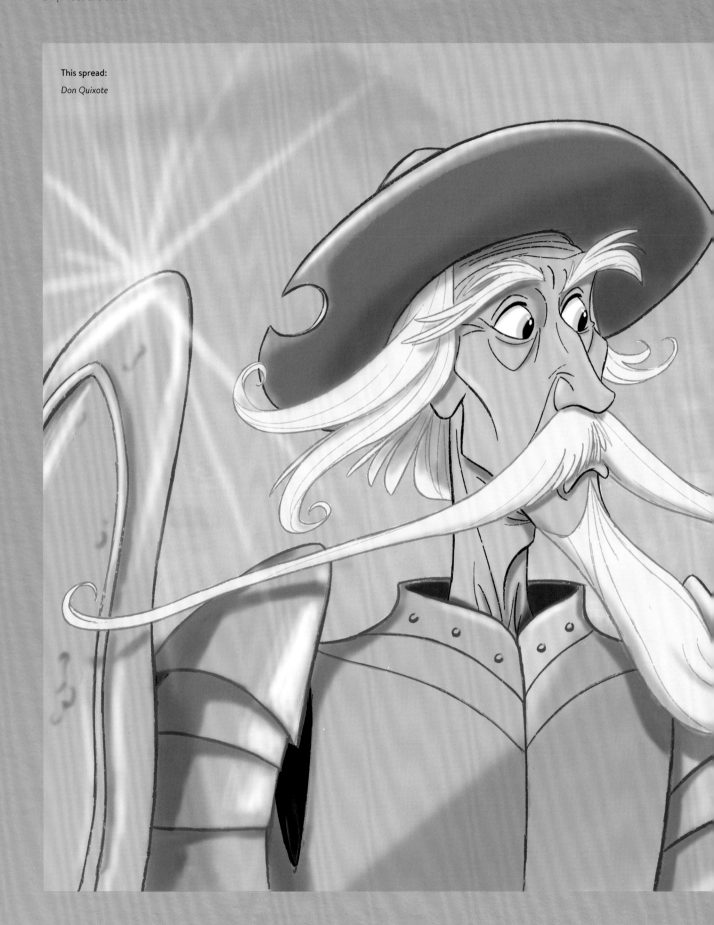

This spread:

Don Quixote

What do you consider to be the most important elements of character design and bringing characters to life?

For me, the key element is personality. You can have a fancy drawing with lots of detail, but you look at it and feel nothing because there's no personality. You need to consider who the character is you are drawing, and what their motivation is. Knowing where and how the character fits into the story makes all the difference and will lead to much more interesting designs. It's the same with animation. It's easy to move a character around the screen, but it's very difficult to make a character actually move the audience – for that, you need to inject personality.

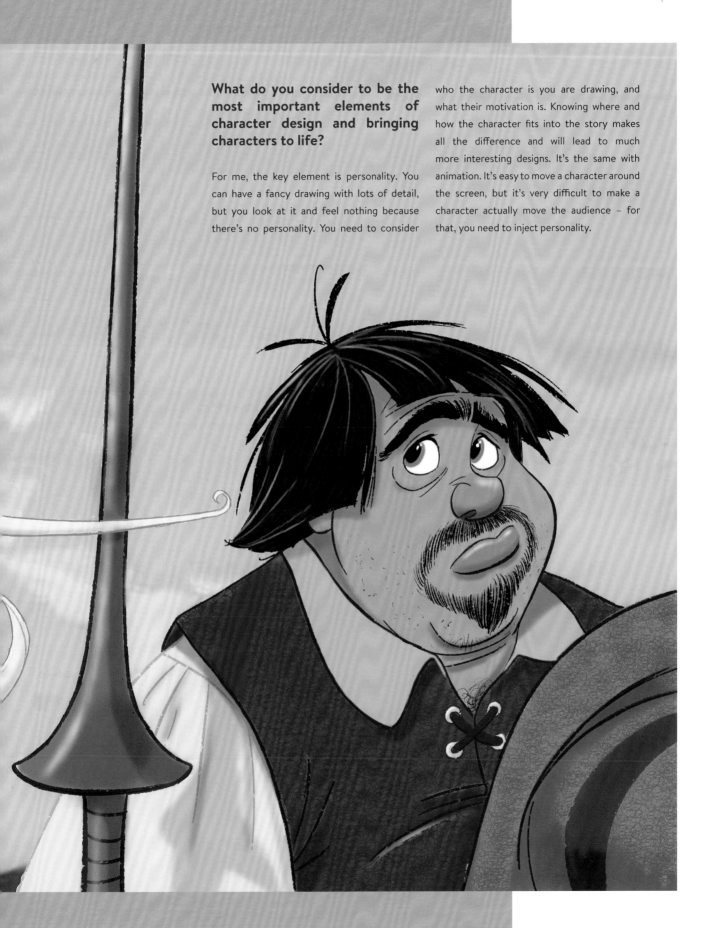

What are the independent challenges you face as someone who has seen the industry develop as much as it has since you first started your career?

For me, the challenge is always the technology – there's always something new to learn. Also, competition is at an all-time high and you need to make yourself seen, especially if you're a freelancer. You have to be engaged with all the social-media platforms, posting your work constantly which, for me, is not easy. Animation work also tends to be on a project-to-project basis these days, so you constantly need to be thinking about where you're going to work next.

If you could go back and give your younger self a piece of advice, what would it be? Was there a project you wish you had taken, or something you wish you had done sooner rather than later?

If I could, I would force my younger self to make his own animated short film. It's something I miss and I would still like to do and get it out of my system. As for a project I wish I had taken, I would say Disney's *Zootopia*. I was offered a role as part of the design team, but I couldn't take it at the time. That film is absolutely the style that I love to work with.

What new projects should we look out for in 2021?

Make sure to look out for Warner Brothers' *Space Jam: A New Legacy* and a beautiful Brazilian animated film called *Perlimps*, from the director of *Boy and the World*. The latter is a very artistic work and a totally different design style than mine, but as I said before, I love to change styles when I can.

This page:

The Meeting

Opposite page:

A new friend

THE PERSONALITY TEST

ILSE HARTING

As character designers, we all aim to create authentic characters that are expressive and full of personality. Here are a few tips on making that happen. I've created a couple of new characters to showcase the important steps. Let's get started!

STRAIGHT INTO THE ACTION

When designing a character, choosing the right shapes to match their personality is key, and making a note of how they carry these shapes is perhaps even more important. Whenever possible, I start sketching new characters mid-action, as this helps to visualize the range of motions and expressions they might use. The girl in this drawing is a simple sketch, but by drawing her in motion I can already get a sense of what kind of person she might be.

COLOR BLOCKING

It's a good idea to block in the character with colors as soon as possible, so you can read their shapes and silhouette better. I always give the character what I consider their primary color first, and from there I have a general direction for the color palette to evolve as I move forward with the design.

ADDING COLORS STEP BY STEP

This is where choosing one primary color helps! Instead of giving a character four, five, or more colors right from the start, try beginning with a single color and slowly adding more as you go along. Every color I pick is based on my original choice of orange. By doing this gradually, you won't get overwhelmed with color choices, and the design won't become too busy.

ALL THE PAGE IS A STAGE

Viewing your characters as actors auditioning for a part in a play is a good method for getting a little deeper into their personality. Ask your characters questions beyond the role you've assigned them. What interesting quirks do they have? What troubles them? What strengths and flaws make them unique? Once you've formed a rounded personality, see how these decisions can affect the character's design. By going back and forth between developing the personality and the physical traits again and again, you can turn the most generic design into something truly original.

DRESSING UP YOUR CHARACTERS

Pinterest is often cited as a great source for reference material for all sorts of projects, and rightfully so. But when looking specifically for clothing, I like to search for references via online clothing stores. Browsing a store's catalog can lead you to a wide range of variations on different designs, and better still, the quality of the photos can be excellent. With close-ups, different angles, and sometimes even 360° videos where you can see how the model moves in the garment, online stores can be extremely helpful when trying to find that perfect outfit for your characters.

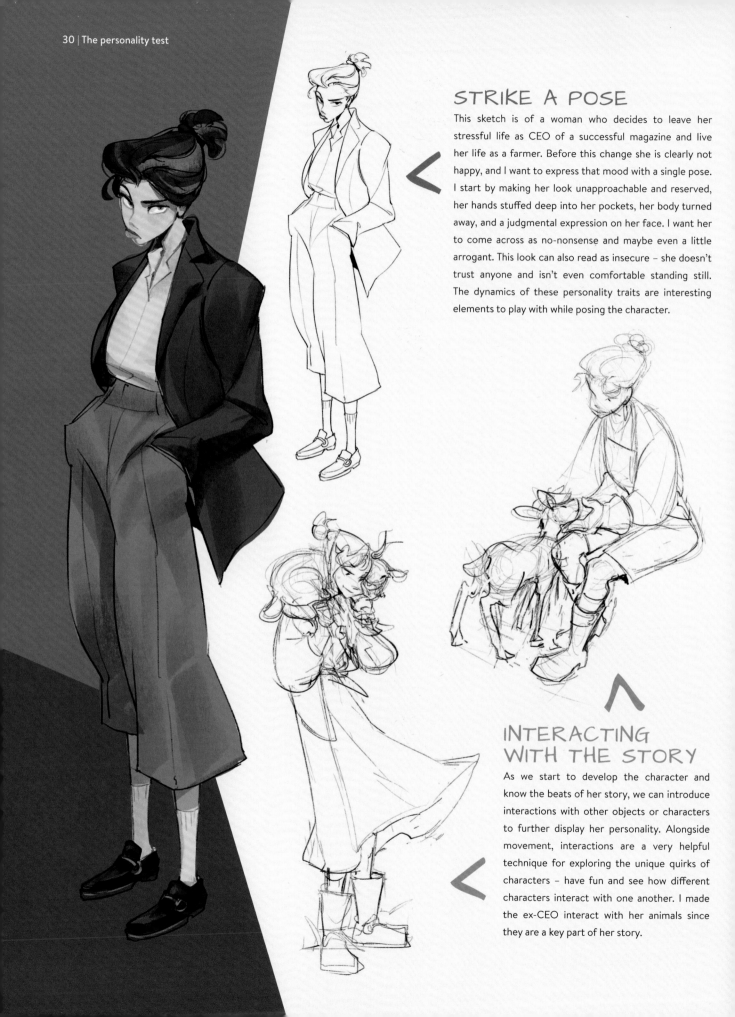

STRIKE A POSE

This sketch is of a woman who decides to leave her stressful life as CEO of a successful magazine and live her life as a farmer. Before this change she is clearly not happy, and I want to express that mood with a single pose. I start by making her look unapproachable and reserved, her hands stuffed deep into her pockets, her body turned away, and a judgmental expression on her face. I want her to come across as no-nonsense and maybe even a little arrogant. This look can also read as insecure – she doesn't trust anyone and isn't even comfortable standing still. The dynamics of these personality traits are interesting elements to play with while posing the character.

INTERACTING WITH THE STORY

As we start to develop the character and know the beats of her story, we can introduce interactions with other objects or characters to further display her personality. Alongside movement, interactions are a very helpful technique for exploring the unique quirks of characters – have fun and see how different characters interact with one another. I made the ex-CEO interact with her animals since they are a key part of her story.

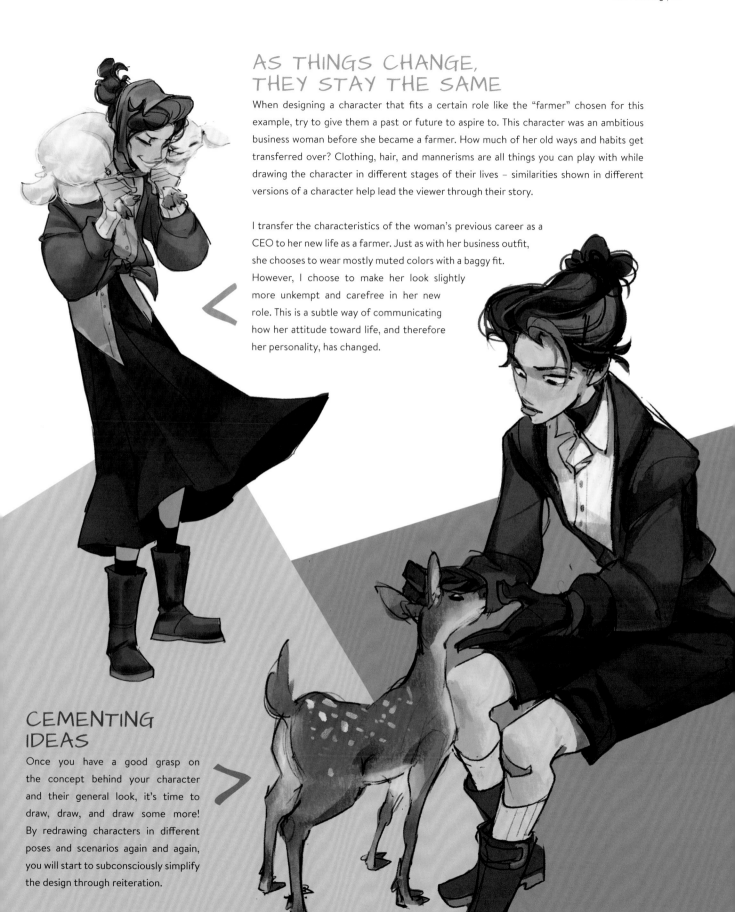

AS THINGS CHANGE, THEY STAY THE SAME

When designing a character that fits a certain role like the "farmer" chosen for this example, try to give them a past or future to aspire to. This character was an ambitious business woman before she became a farmer. How much of her old ways and habits get transferred over? Clothing, hair, and mannerisms are all things you can play with while drawing the character in different stages of their lives – similarities shown in different versions of a character help lead the viewer through their story.

I transfer the characteristics of the woman's previous career as a CEO to her new life as a farmer. Just as with her business outfit, she chooses to wear mostly muted colors with a baggy fit. However, I choose to make her look slightly more unkempt and carefree in her new role. This is a subtle way of communicating how her attitude toward life, and therefore her personality, has changed.

CEMENTING IDEAS

Once you have a good grasp on the concept behind your character and their general look, it's time to draw, draw, and draw some more! By redrawing characters in different poses and scenarios again and again, you will start to subconsciously simplify the design through reiteration.

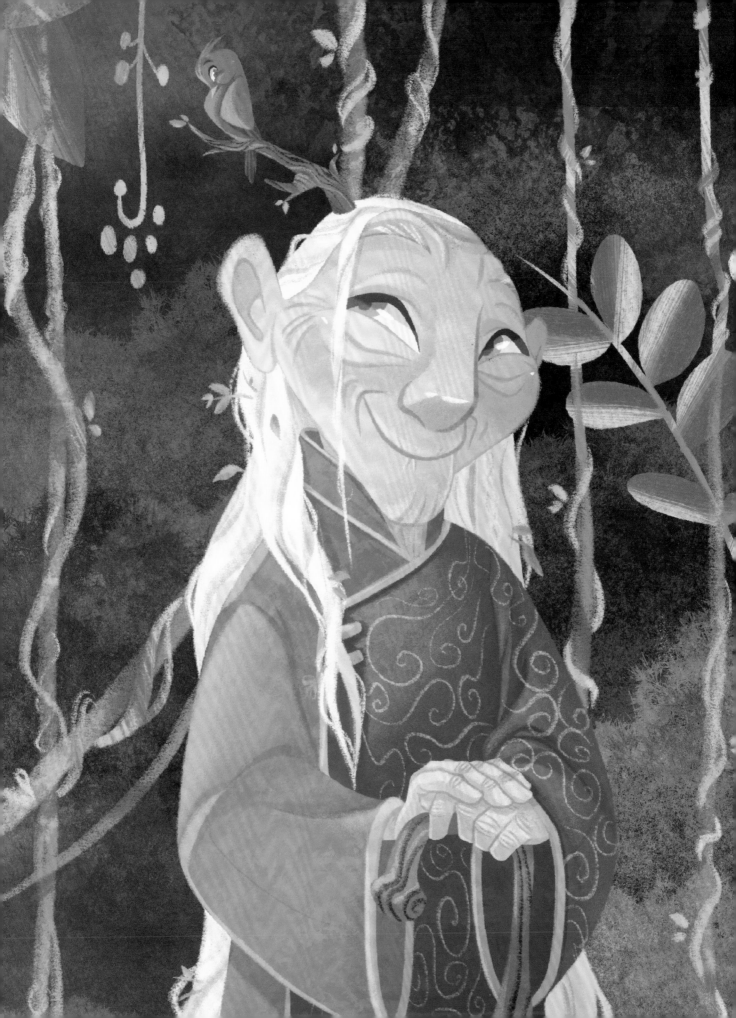

REIMAGINING MOTHER NATURE
MARGANA (AKA MARTA GARCIÁ NAVARRO)

Being able to re-imagine characters is one of my favorite things about being an illustrator. When you hear a story or read a book, your mind can't help but imagine how the characters might look. That's the magic of reimagining a character – even though there may be many drawings or interpretations of Red Riding Hood, for example, you can always change whatever you dislike and redesign the character as your imagination desires. In this tutorial, I'm designing a new take on Mother Nature, and I inevitably have *Moana's* goddess Te Fiti in mind. But I start thinking about my own design. Mother Nature has always been there, right? She must be old...

THE SAME, BUT DIFFERENT

When I design a character that is not originally mine, I always do some research on the various interpretations of them already covered. For example, take Hansel and Gretel – you can think of the innocent little siblings or the older witch-hunter movie version of them. We're doing the same with Mother Nature. As I said, I have Te Fiti in mind, but we want our character to stand out and be different from other designs. With that in mind, I try sketching different basic shapes, from rectangles to circles, from tall to short. I don't waste time with details at this stage and just draw quick, rough sketches of the idea and let my mind wander.

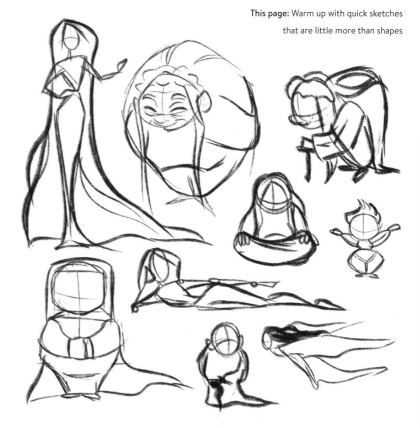

This page: Warm up with quick sketches that are little more than shapes

AN IDEA TAKES SHAPE

When you're creating a character, you have to be open to extreme shapes. Try the silhouette technique, which involves drawing random opaque forms to use as the character's outline. This practice allows you to expand your possibilities when looking for the perfect design – it's an easy and very popular technique used by many illustrators and character designers. I always start with basic shapes (as shown in step one), but now I try to add a little more detail to them, defining limbs and hairstyles. Don't be afraid of extremes with these early sketches; try drawing unproportioned shapes and experiment with various sizes of the character.

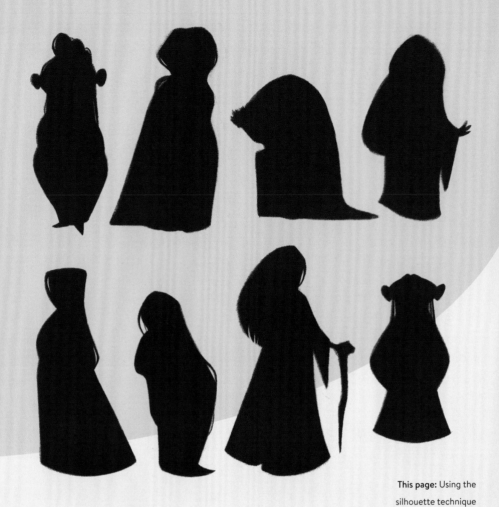

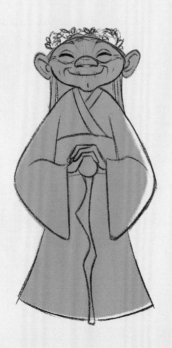
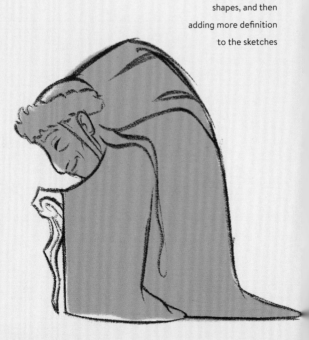

This page: Using the silhouette technique to find successful shapes, and then adding more definition to the sketches

UNEARTHING MOTHER NATURE

Now that I've drawn several sketches and silhouette ideas for the character, I choose one or two I like best and create thumbnails based on them. At this stage, it's fine to draw different poses and add props, for example a walking stick, but I still need to keep things simple. Do I want Mother Nature to be big or small, tall or short? Does she have wings, or wear a kimono? I want to create a unique and original take on the character, so I need to take all the preconceptions of Mother Nature and flip them on their head to make her stand out from other designs. I decide that I want her to look like a wise old grandma.

This page: Drawing thumbnails and settling on a general design idea

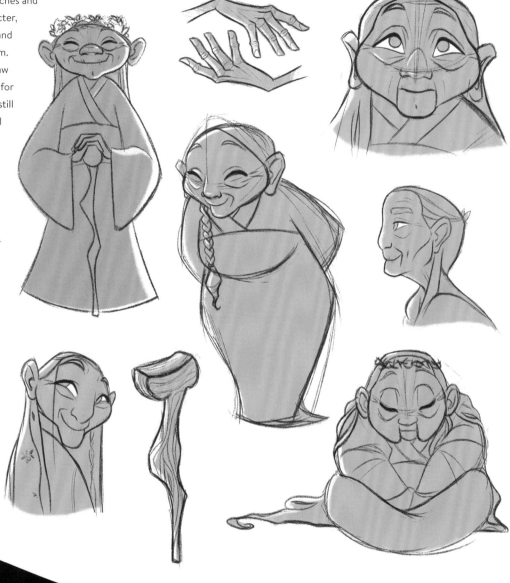

THAT CERTAIN SOMETHING

"Appeal" is that essential something that every character must have. I don't mean "pretty," but interesting to look at. Think of The Little Mermaid's villain, Ursula. She's not conventionally attractive, but she has that special something that makes her an interesting character from a designer's point of view. Her sass, expressions, big and round shape, all combine to make her appealing. For this step, it's important to use references. If you find yourself having trouble drawing an expression, for example, do some research and base your drawing on a reference photo or picture. And don't worry, it's not cheating! In my opinion,

EXPRESS YOURSELF!

Now I want to capture the expressions that come to mind when I think about my character. Having a background story in mind is useful when trying to make them look more believable. This is a very important part of the process, because choosing an expression for a character determines their personality and shows part of their story. In this instance, I have no story or description to work from, no brief from an agency or studio describing how I need to reimagine Mother Nature, so it's up to me to decide if I make her good or bad... It all depends on the story you have in your head! At this stage, I usually draw four different expressions from different angles.

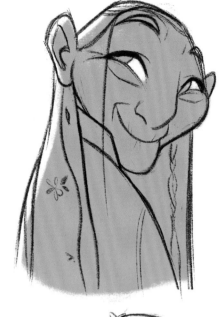

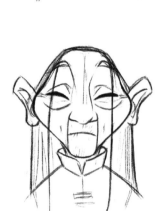

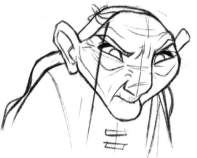

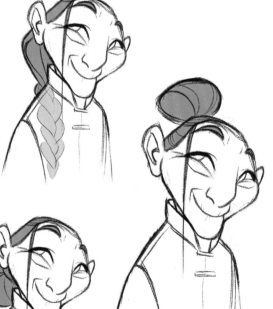

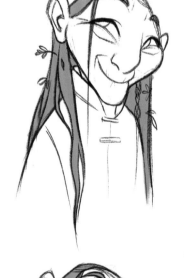

HAIR-RAISING IDEAS

Hairstyle could be considered a small detail, but actually it can say a lot about a character. A Mohawk could imply the character is a punk or a biker for example. Even if I have a specific hairstyle in mind, I like to draw several and compare them on the canvas. I want Mother Nature to have wild, long, white hair, so that's the first hairstyle I draw. But then I draw a second and third and I like them better – it's always good to get out of your comfort zone, you never know what you might discover!

This page (top): Expressions start to bring the character to life

This page (bottom): Different hairstyles can change the whole look of a character

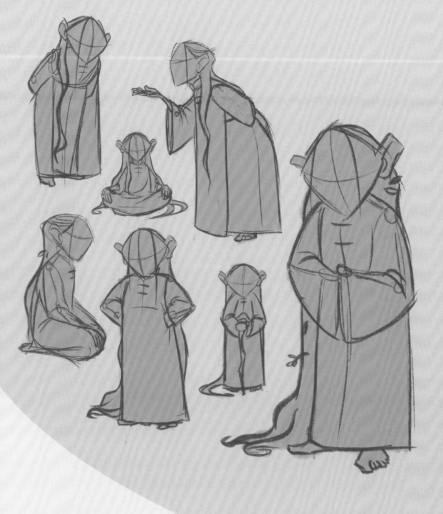

STRIKE A POSE

Like hairstyles, the pose is a key aspect of a character's personality. If you want a character to look shy, you can't draw them jumping with their arms and limbs wide open. The pose has to be in keeping with the character's personality and what you want to show about it. Of course, a character's personality can change throughout their narrative, and it's up to you to decide what particular moment you want to show. My Mother Nature is calm, patient, and slow, so I try drawing her in both standing and seated positions to reflect those characteristics.

DRESSING FOR THE OCCASION

Clothing can convey a lot about a character's personality and the story you're trying to tell. Maybe a character is forced to wear a dress for a special occasion, even though she hates wearing dresses, for example. When choosing an outfit, I start by drawing a simple design and then gradually start adding details. I want my Mother Nature to wear a dress, so I draw basic lines with different lengths, and then add various details to see which look better on her. I try long sleeves, a sash, flowers all over, and different patterns.

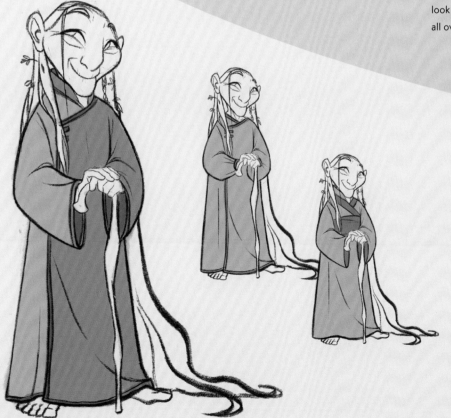

This page (top): Choosing poses to define the character's personality

This page (bottom): Clothing can be a defining part of a character's identity

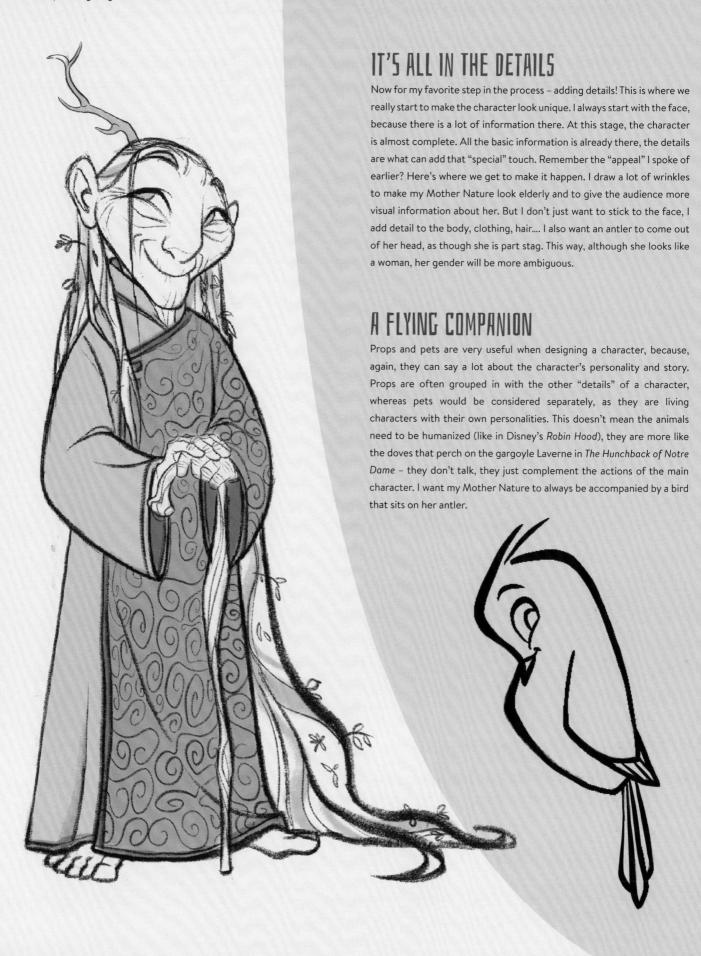

IT'S ALL IN THE DETAILS

Now for my favorite step in the process – adding details! This is where we really start to make the character look unique. I always start with the face, because there is a lot of information there. At this stage, the character is almost complete. All the basic information is already there, the details are what can add that "special" touch. Remember the "appeal" I spoke of earlier? Here's where we get to make it happen. I draw a lot of wrinkles to make my Mother Nature look elderly and to give the audience more visual information about her. But I don't just want to stick to the face, I add detail to the body, clothing, hair.... I also want an antler to come out of her head, as though she is part stag. This way, although she looks like a woman, her gender will be more ambiguous.

A FLYING COMPANION

Props and pets are very useful when designing a character, because, again, they can say a lot about the character's personality and story. Props are often grouped in with the other "details" of a character, whereas pets would be considered separately, as they are living characters with their own personalities. This doesn't mean the animals need to be humanized (like in Disney's *Robin Hood*), they are more like the doves that perch on the gargoyle Laverne in *The Hunchback of Notre Dame* – they don't talk, they just complement the actions of the main character. I want my Mother Nature to always be accompanied by a bird that sits on her antler.

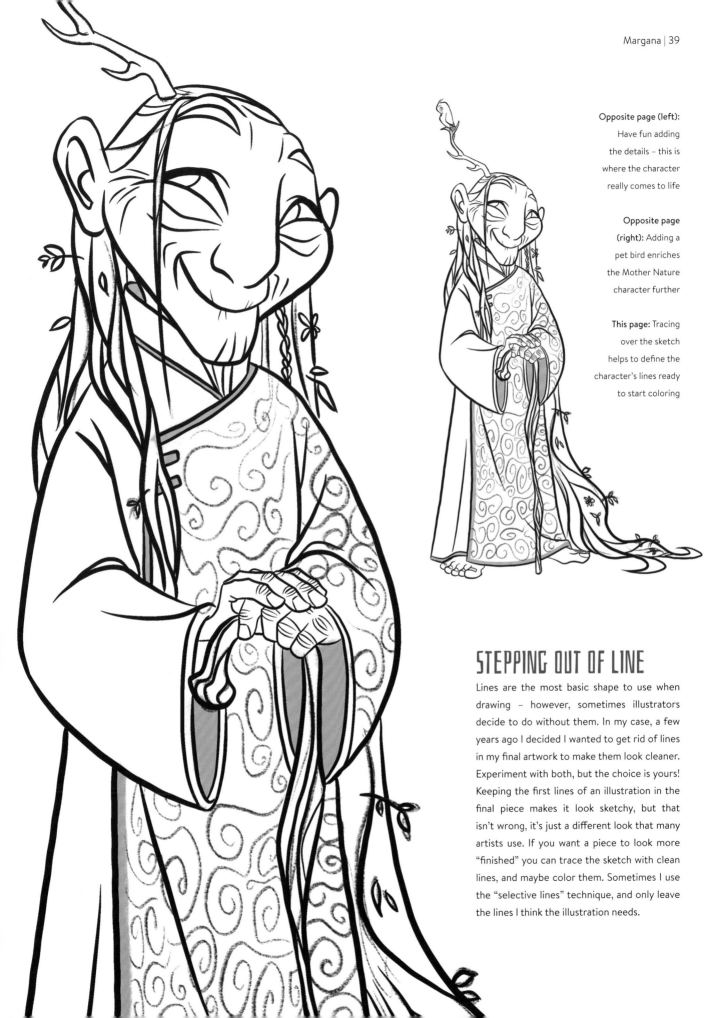

Opposite page (left): Have fun adding the details – this is where the character really comes to life

Opposite page (right): Adding a pet bird enriches the Mother Nature character further

This page: Tracing over the sketch helps to define the character's lines ready to start coloring

STEPPING OUT OF LINE

Lines are the most basic shape to use when drawing – however, sometimes illustrators decide to do without them. In my case, a few years ago I decided I wanted to get rid of lines in my final artwork to make them look cleaner. Experiment with both, but the choice is yours! Keeping the first lines of an illustration in the final piece makes it look sketchy, but that isn't wrong, it's just a different look that many artists use. If you want a piece to look more "finished" you can trace the sketch with clean lines, and maybe color them. Sometimes I use the "selective lines" technique, and only leave the lines I think the illustration needs.

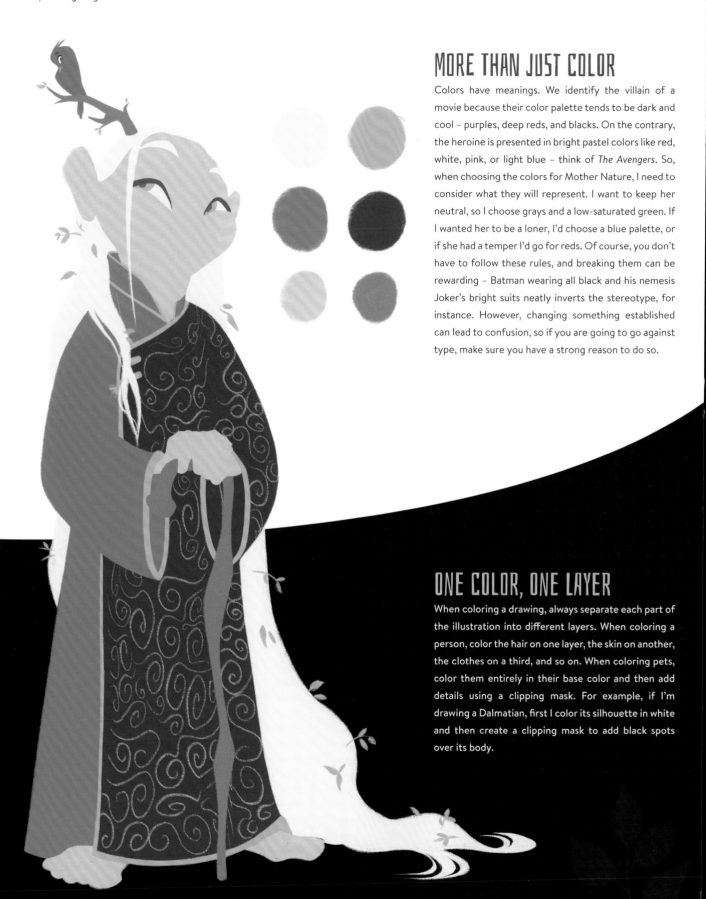

MORE THAN JUST COLOR

Colors have meanings. We identify the villain of a movie because their color palette tends to be dark and cool – purples, deep reds, and blacks. On the contrary, the heroine is presented in bright pastel colors like red, white, pink, or light blue – think of *The Avengers*. So, when choosing the colors for Mother Nature, I need to consider what they will represent. I want to keep her neutral, so I choose grays and a low-saturated green. If I wanted her to be a loner, I'd choose a blue palette, or if she had a temper I'd go for reds. Of course, you don't have to follow these rules, and breaking them can be rewarding – Batman wearing all black and his nemesis Joker's bright suits neatly inverts the stereotype, for instance. However, changing something established can lead to confusion, so if you are going to go against type, make sure you have a strong reason to do so.

ONE COLOR, ONE LAYER

When coloring a drawing, always separate each part of the illustration into different layers. When coloring a person, color the hair on one layer, the skin on another, the clothes on a third, and so on. When coloring pets, color them entirely in their base color and then add details using a clipping mask. For example, if I'm drawing a Dalmatian, first I color its silhouette in white and then create a clipping mask to add black spots over its body.

ADDING DEPTH

Now we need to focus on shadows. Shadows make our characters pop out from the page, thanks to the volume they provide. In my drawings, shadows are essential as they separate the parts of my lineless characters. Lighting and shadow give information about the environment, too. For example, if I use a pink light and a purple shadow on my character, you might think she is close to some magical place at night. The hardness of the shadow can also tell us something about the setting – making it more dramatic if the shadow is almost opaque, or making things seem calmer and friendlier if the shadow is less noticeable.

Opposite page:

Choosing a basic color palette for Mother Nature

This page (top):

With depth added via shadows, Mother Nature starts to come to life

This page (bottom):

Secondary lighting gives further volume to the character

LIGHT IN THE DARKNESS

Lighting and shadows are always connected, but that doesn't mean you have to see them both on an illustration. I find lighting more important because without light, there would be no shadows, but I don't always capture light in my illustrations, whereas shadows are fundamental. Light is always present in a drawing, even if you don't actually draw it – shadows suggest light where they are not. However, we can add a secondary light – a supporting light that, like shadows, makes the character pop from the page.

EYE POSITION

The position of the eyes can change a character completely. I always draw them on a different layer and put them in various positions to see which suits best. When I draw kids, I tend to place the eyes further apart than I will with an adult. If you try moving them around you will quickly see how different a character can look. This tip also works when deciding how big the eyes should be.

A NEW DAWN

Mother Nature is colored and the lighting and shadows are placed correctly, so all that's left is to add the finishing touches. Ideally, these are what give the illustration a 3D effect. I use different brushes to create textures, adding gleams on the eyes and the top of the nose. I also like to add redness on the character's shoulders, elbows, and cheeks to make their skin look more natural and realistic, and not so balanced. This can make a character look cuter as well, especially when they are babies. And with that, Mother Nature is finished!

This page: The finished character with final touches to give her a 3D look

Opposite page: The finished character with a simple background added

Final image © Marta Garciá Navarro

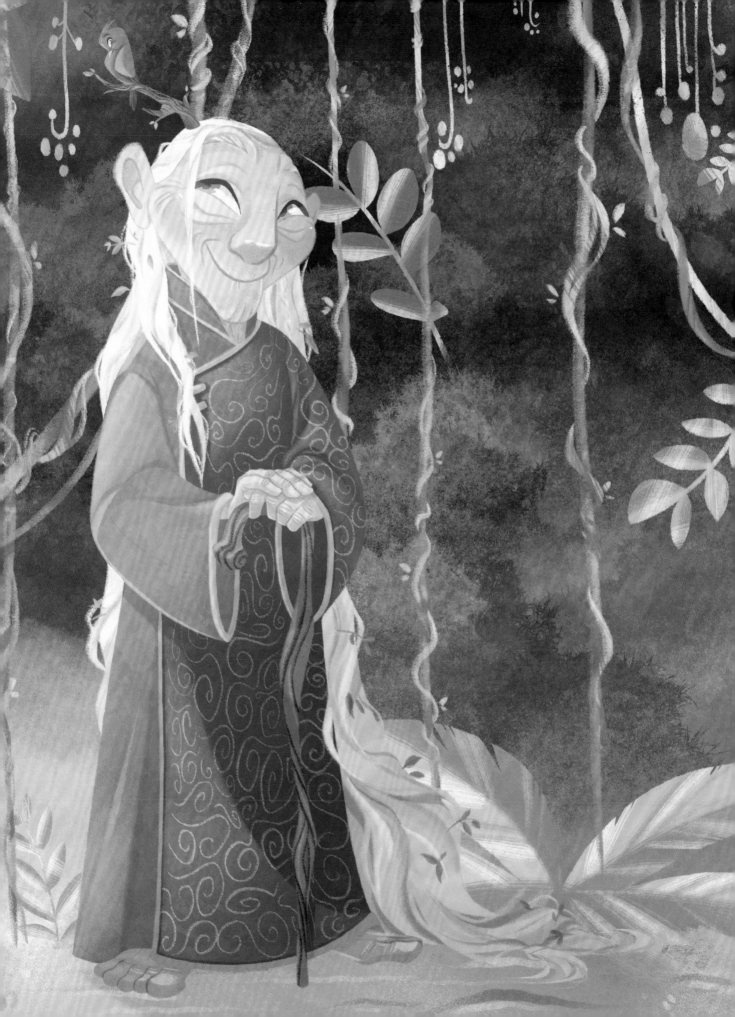

COMMUNITY SPOTLIGHT:

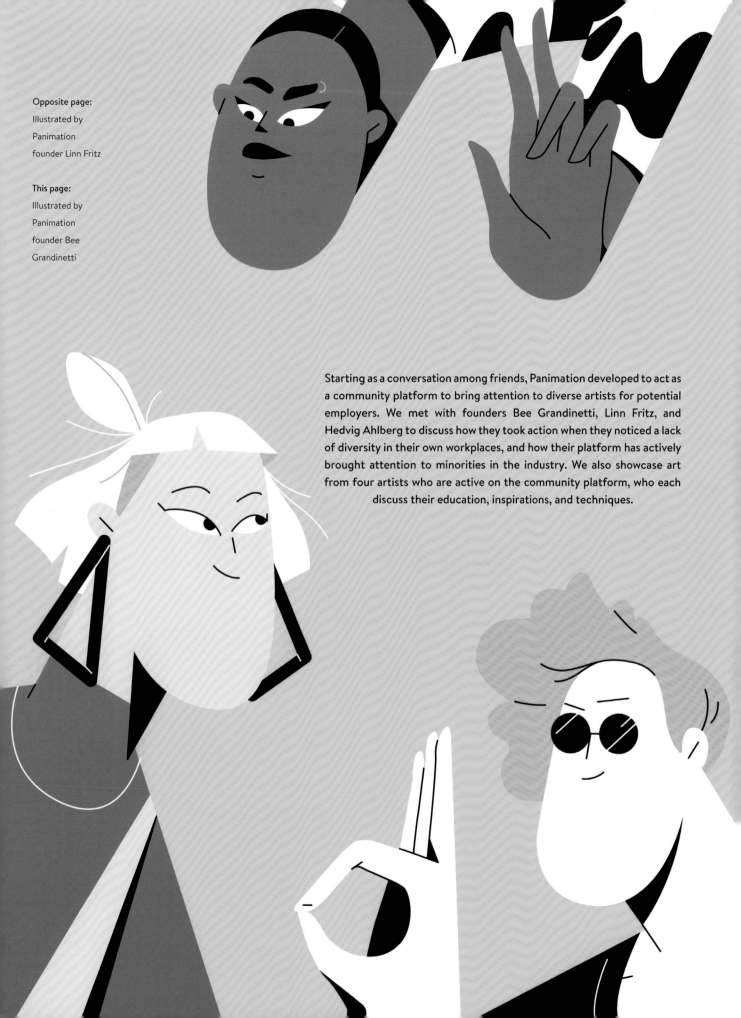

Opposite page:
Illustrated by
Panimation
founder Linn Fritz

This page:
Illustrated by
Panimation
founder Bee
Grandinetti

Starting as a conversation among friends, Panimation developed to act as a community platform to bring attention to diverse artists for potential employers. We met with founders Bee Grandinetti, Linn Fritz, and Hedvig Ahlberg to discuss how they took action when they noticed a lack of diversity in their own workplaces, and how their platform has actively brought attention to minorities in the industry. We also showcase art from four artists who are active on the community platform, who each discuss their education, inspirations, and techniques.

Hi there, thank you so much for talking to us today. Could you give us a brief explanation of Panimation and what you aim to achieve as a platform?

Panimation (previously known as Punanimation) is a multi-platform community for women, trans, and non-binary people working in animation and motion graphics. It was founded by the three of us in 2015 – we were tired of complaining about the industry being too much of a boys' club and so decided to do something about it.

What started as a small Facebook group, aiming to connect a few friends, grew to become a community with over 5,000 members from all over the globe. We use our Instagram account to showcase diverse work from creators every week, and in 2017 we launched a directory

to help decision-makers find more diverse talent. Panimation has also grown beyond the digital space – today, we host physical meet-ups, screenings, and events in several different cities around the world. Our main goal is to connect, support, and promote these minorities, spreading awareness and taking any steps we can toward making the industry more diverse.

How did your own careers as creatives begin and develop – and lead to you creating Panimation?

When we started Panimation, we were all at the very beginning of our careers, working in internships and junior positions at different studios across London. The three of us quickly became close friends and would meet for drinks pretty much every week. We would talk about our

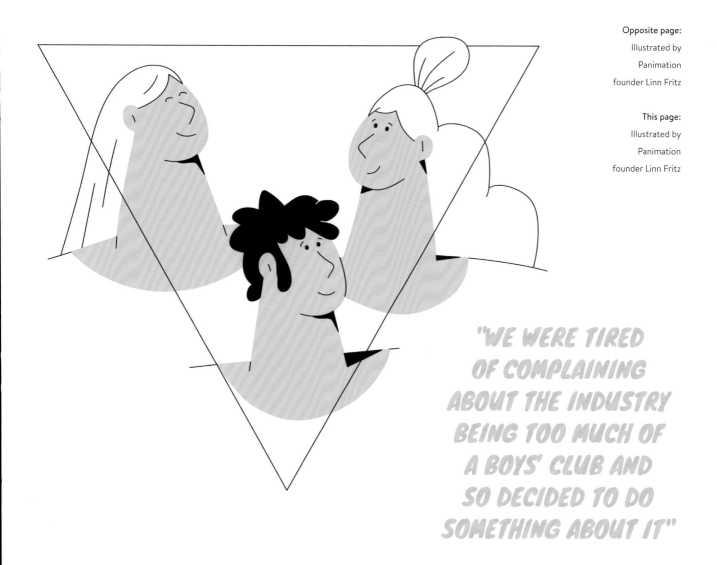

"WE WERE TIRED
OF COMPLAINING
ABOUT THE INDUSTRY
BEING TOO MUCH OF
A BOYS' CLUB AND
SO DECIDED TO DO
SOMETHING ABOUT IT"

frustrations at work, and we began to notice that our experiences and the weird situations we found ourselves in weren't just isolated incidents, they were definite patterns. Having that space and time together to openly share, validate, and help each other was so valuable to us, we thought it would be awesome if more people were able to have that too. So, we started the Facebook group and invited a few other friends from the industry to join us.

What do you consider to be the more rewarding aspects of running a business that strives to highlight minorities within the industry?

We don't consider Panimation a business, as we all still have our normal full-time jobs and work on Panimation on a volunteer basis, in our spare time. We make absolutely no profit from it. However, we're thrilled to keep on doing this even after almost six years, because the whole community has accomplished so much more than we ever thought possible. We've experienced firsthand how much stronger we can be when we combine our forces – it's a cliché, but it's true! We've seen people growing, learning, connecting, and collaborating with each other, helping others to find new jobs, recommending peers for different roles, and offering and receiving emotional support in difficult times. We've even seen people able to buy houses because of how much support the network has given them with finding more work. It's a magical feeling, seeing how much change can be sparked from such small conversations and modest beginnings. You can't put a price on experiences like this.

Since you've started, have you noticed an increase in diversity within these industries?

Yes, we believe the industry today is at a much better place than when we started Panimation, six years ago. It's becoming increasingly easy to recommend more diverse, talented peers across a whole range of different skills. We are constantly strengthening our bonds, getting to know each other better, amplifying our network, and growing more confident in our skills. When we first started working in our respective studios, it was rare to find another woman who was also a creative – if there were female employees, they would often be in production roles. It's refreshing to see this slow but steady shift happening, and there are definitely increasingly balanced teams forming as time goes on.

There was a real lack of diverse role models when we started, and while there still is to some extent, we can definitely feel it changing. Positions of power and director rosters within

the industry have notoriously been dominated by white, straight, cis men, but today we can name lots more diverse people to look up to. It's clear that studios and agencies are actively getting worried about the need to modernize their teams and are now actively pursuing diverse hires.

What do you see as the most important aspects of creating a community for artists? And how do those involved use your platform for their work?

Community is everything – it's incredibly hard to thrive and remain happy and inspired in an environment where you feel like you don't fit in. Communities make us feel connected, understood, safe, and cared for. Once we feel protected, we also become more comfortable with being vulnerable and sharing our fears, challenges, and doubts. Our platforms are used in many ways to facilitate conversations around these concepts. Our members continually help each other with matters

such as how much to charge for a job, how to phrase an important email, or how to stand up for themselves in a complex work situation. We also offer technical help, job posts, news, inspiration, feedback on work, and so on.

Opening ourselves to receive support is ultimately how we grow, learn, and overcome our difficulties and it's beautiful to see that we've created a space where so many people feel comfortable doing so. We think people tend to underestimate the power of small actions and short conversations. These tiny droplets ripple out and create big waves.

What types of industries do the artists on your platform work within? Is there a wide range of skills and job roles represented?

We're admittedly more connected to the commercial side of the industry, where animation and motion graphics often meet. Since the three of us came from that background, it's where our origins lie and

Opposite page:
Illustrated by
Panimation founder
Bee Grandinetti

This page: Illustrated
by Panimation
founder Linn Fritz

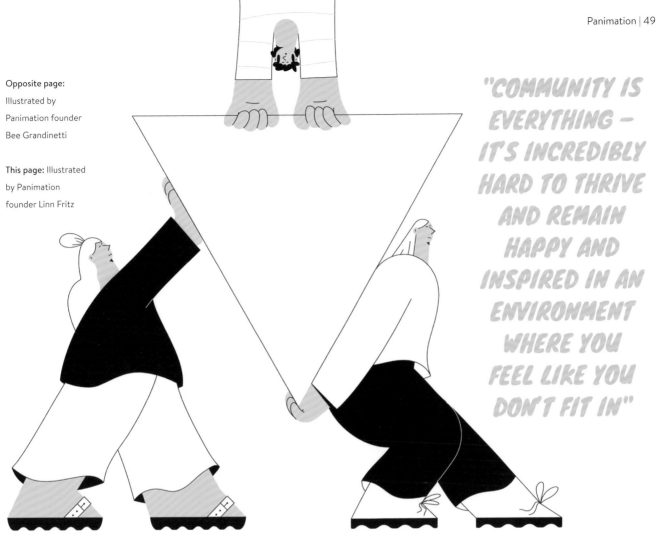

"COMMUNITY IS EVERYTHING – IT'S INCREDIBLY HARD TO THRIVE AND REMAIN HAPPY AND INSPIRED IN AN ENVIRONMENT WHERE YOU FEEL LIKE YOU DON'T FIT IN"

where we knew more people to begin with. Within that area, there are so many roles and specializations. We have animators, designers, directors, producers, studio owners, editors, storyboard artists, prop makers, sound designers, compositors, recruiters... People working with 2D, 3D, stop motion, puppets, character animation, UI/UX, AR, VR... We have members who are still at school (or maybe even just flirting with the idea of changing fields and studying animation) and a lot of seasoned professionals too – it's definitely a wide field! In the past few years, we've also been connecting more with other segments of the industry, such as animation for films and series, which has a completely different culture and pipeline.

I'm sure there are many upcoming artists that would love to get involved – how exactly would they do that?

All women, trans, and non-binary people working within the industry are welcome to join our platforms and get involved in the conversations there. It's as easy as Googling us and pressing the join button! We like to keep Panimation more decentralized and independent, so members are welcome to start chapters in their own cities and organize meet-ups themselves.

We run Instagram takeovers and get a lot of helpful recommendations from our community, but we're always looking for hidden talents to signal-boost. If anyone is interested in doing a takeover they can always email us at instagram@panimation.tv.

We also have a Patreon page where people can chip in and help us raise funds for exciting bigger plans we're hoping to make come true in the near future.

MEET THE ARTISTS

BIANCA BENEDUCI ASSAD

Job title
Illustrator and animator

Education
I studied Classical Animation at Vancouver Film School and Visual Media at London College of Communication.

Inspiration
My biggest inspiration comes from people: friends, musicians, people I see walking around the city. And my crazy border collie Lulu, of course!

Techniques
I mainly work on Procreate and Photoshop for design. For animation, I use Animate, Photoshop and a tiny bit of After Effects.

Opposite page: *East London* by Bianca Beneduci Assad

This page (top left): *Call Your Friends* by Bianca Beneduci Assad

This page (top right): *Solange* by Bianca Beneduci Assad

This page (bottom): *Big Hug* by Bianca Beneduci Assad

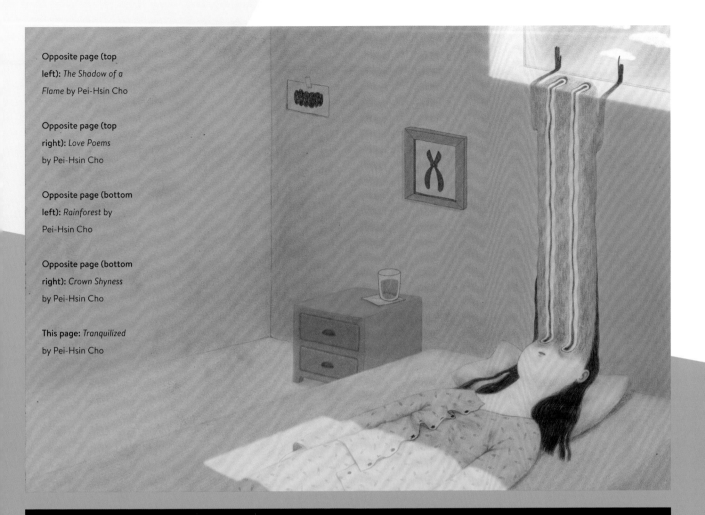

Opposite page (top left): *The Shadow of a Flame* by Pei-Hsin Cho

Opposite page (top right): *Love Poems* by Pei-Hsin Cho

Opposite page (bottom left): *Rainforest* by Pei-Hsin Cho

Opposite page (bottom right): *Crown Shyness* by Pei-Hsin Cho

This page: *Tranquilized* by Pei-Hsin Cho

PEI-HSIN CHO

Job title
Freelance illustrator and animator

Education
I was born and raised in Taiwan and have loved drawing since I was very little. I went to study animation at National Taipei University of the Arts, and after a year of freelancing I pursued an MA in visual communication at the Royal College of Art in the UK.

Inspiration
Most of my inspirations come from life, whether it's big, world-changing events or little moments like the daylight moving across my room. I'm especially interested in exploring themes surrounding mental health, psychology, and introspection and will approach different topics with these ideas in mind.

Techniques
I love to use graphite and other types of pencils. The organic marks that graphite leaves on paper is irreplaceable to me, the sound and feel of drawing and smudging on the paper are really satisfying. Even when drawing digitally, I tend to mimic pencil drawings, but digital drawings can be more convenient and efficient for quick turnaround commissions. I try leveraging the best traits of both traditional and digital mediums.

HÉLOÏSE COURTOIS

Job title
CG artist and illustrator

Education
After high school, I enrolled in a 3D animation school in Arles, France. Then I studied my master's at the École des Nouvelles Images in Avignon, where I directed my first film Grand Bassin as part of my final year and diploma.

Inspiration
I get a lot of inspiration from the people around me – my friends and my family – but also from everyday life situations. I also love fashion and will draw inspiration from an incredible style or outfit that I've seen. There are many artists I find inspiring, whether in fashion, illustration, tattoo, ceramics, music, and so on.

Techniques
I use the 3D software I learned during my education. 3D allows an infinite number of possibilities to create and experiment, and I like being able to rework a 3D image by adding a painted or photo aspect to it. For my illustrations, I mainly use a graphic tablet, but I also like to draw in my sketchbooks or to paint.

Opposite page:
Gant Blanc by
Héloïse Courtois

This page (top
left): *Naomi* by
Héloïse Courtois

This page (top
right): *Café* by
Héloïse Courtois

This page (bottom):
Neno by Héloïse
Courtois

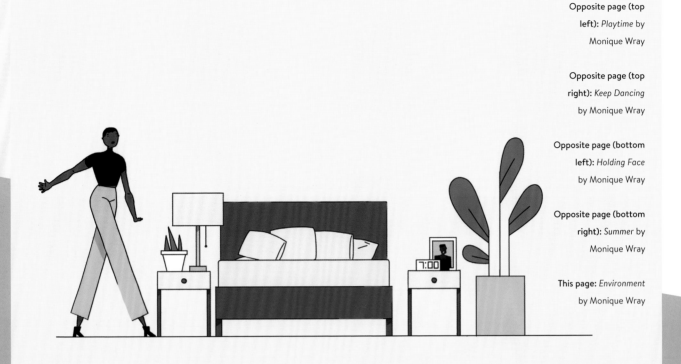

Opposite page (top left): *Playtime* by Monique Wray

Opposite page (top right): *Keep Dancing* by Monique Wray

Opposite page (bottom left): *Holding Face* by Monique Wray

Opposite page (bottom right): *Summer* by Monique Wray

This page: *Environment* by Monique Wray

MONIQUE WRAY

Job title
Illustrator, animator and director working mostly in motion design and editorial

Education
Growing up, I took lessons for painting and drawing in various traditional mediums, as well as photography – it wasn't until college that I began making digital art. I studied Computer Animation and learned to use Maya and Photoshop, which I found to be an excellent foundation for learning other apps.

Inspiration
From a content perspective, I'm inspired by black culture, history, my childhood in Miami, life, music, current events, and creating dialogue around social issues through my work. From an aesthetic point of view, comics are my greatest inspiration, more specifically *The Adventures of Tintin*, *Sailor Moon*, and *Calvin and Hobbes*.

Techniques
I like to start with rough thumbnails on my iPad using Procreate or Clip Studio Paint. Those sketches are then taken to my Cintiq and finished using Clip Studio Paint. When I'm finalizing a drawing, I like to use references that are often of me posing in front of my webcam. I'm thankful for the year I spent in drama class!

GETTING EMOTIONAL:
DESPERATE AND DELIGHTED
HYUN SONG

In this feature, I will talk you through how to showcase the emotions "desperate" and "delighted." Having a good understanding of emotions, and how to portray them in character design, will help make your characters appear more relatable. Here, I will show you how to portray emotions in your designs through shape, expression, and color choices. Let's get started!

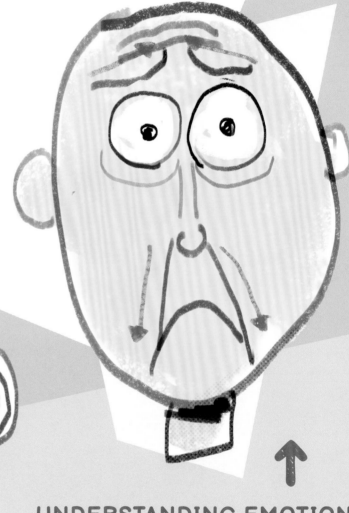

UNDERSTANDING EMOTION

Before we begin, we need to have a solid understanding of the emotions we are trying to express and how they appear on the face. Someone who is desperate will raise their eyebrows, and wrinkles will appear on their forehead. The eyes tend to open up and wrinkles form on both sides of the nose. Often, the mouth also constricts as there is tension in the lower jaw. When it comes to delight, however, the opposite occurs. The sides of the mouth rise upward and the tension is lost, wrinkles form around the eyes as the muscles under the eyes rise up, and the eyes become thinner, expressing joy.

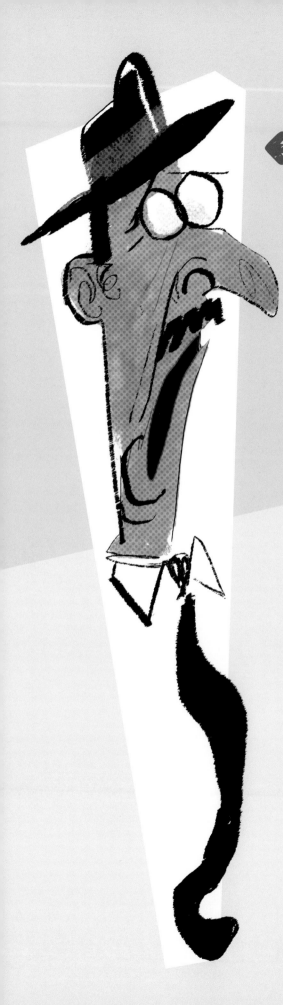

KEEP IT SIMPLE

Once you have an understanding of the visual elements that translate an emotion, you can start applying it to your characters. I begin by sketching out the general shapes of the features I want to highlight to express the emotion, in this case the eyes and the mouth. You can also utilize your character's clothing to reinforce the emotion. Here, I made the tie appear a little damp and limp to reflect the lack of control that coincides with the feeling of desperation.

FLIP THE SCRIPT

For the opposite expression, delight, I flip the design so all the energy is heading upward, rather than down. I mirror the costuming, choosing an upturned cap rather than the more somber trilby hat, and inject color into the design to reflect the vivacious emotion.

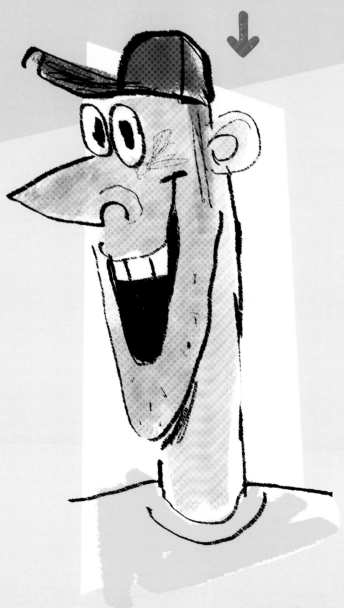

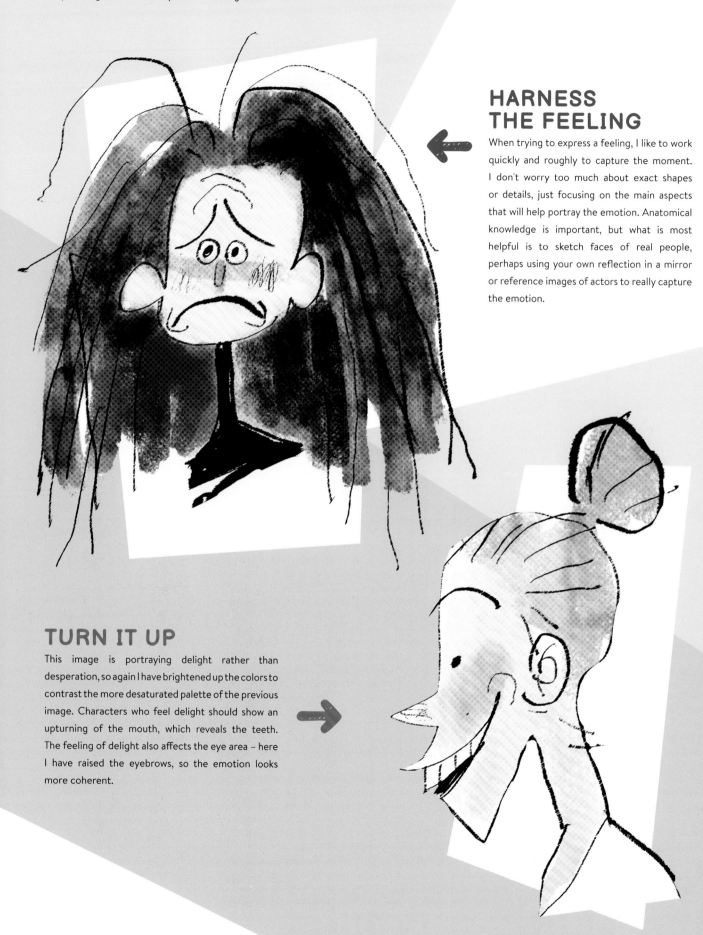

HARNESS THE FEELING

When trying to express a feeling, I like to work quickly and roughly to capture the moment. I don't worry too much about exact shapes or details, just focusing on the main aspects that will help portray the emotion. Anatomical knowledge is important, but what is most helpful is to sketch faces of real people, perhaps using your own reflection in a mirror or reference images of actors to really capture the emotion.

TURN IT UP

This image is portraying delight rather than desperation, so again I have brightened up the colors to contrast the more desaturated palette of the previous image. Characters who feel delight should show an upturning of the mouth, which reveals the teeth. The feeling of delight also affects the eye area – here I have raised the eyebrows, so the emotion looks more coherent.

ANIMALS HAVE FEELINGS TOO!

When trying to portray an animal character with an emotion, we need to assign more human characteristics in order to really sell the feeling. Here, I have made it appear that the dog is clenching its jaw – this is something dogs are unable to do, but I feel it's necessary to communicate the feeling of desperation.

USING SHAPE

As with human expressions, we can communicate feelings in animals by utilizing shape. Here, I have contrasted the desperate dog design and given this dog large, upright ears to mimic the upturned mouth. Animals also have their own set of characteristics that are unique to them and their feelings. For example, a dog with its tongue out is instantly recognizable as a delighted hound.

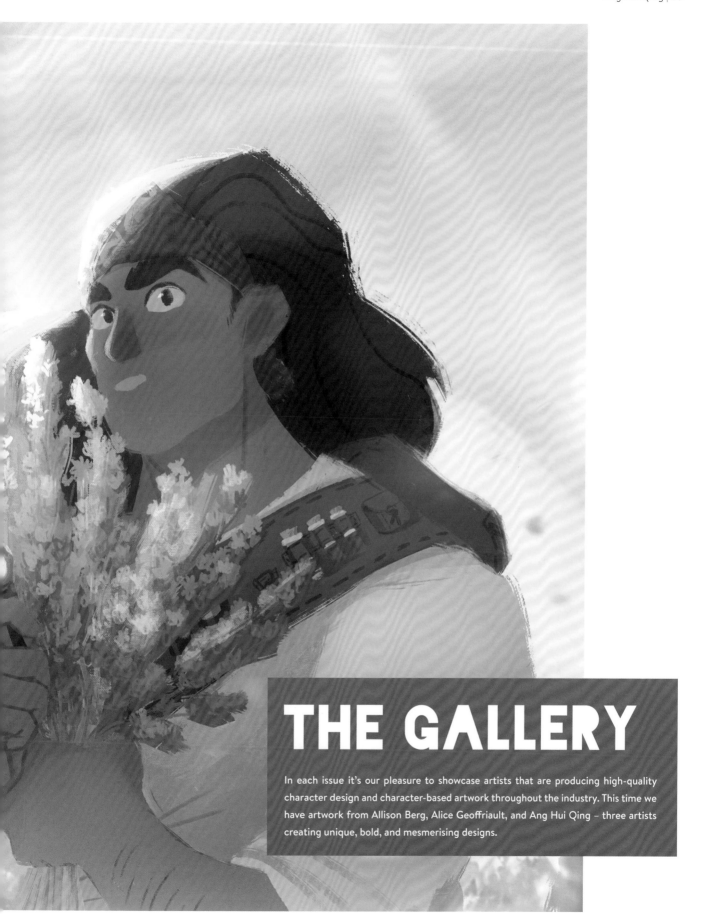

THE GALLERY

In each issue it's our pleasure to showcase artists that are producing high-quality character design and character-based artwork throughout the industry. This time we have artwork from Allison Berg, Alice Geoffriault, and Ang Hui Qing – three artists creating unique, bold, and mesmerising designs.

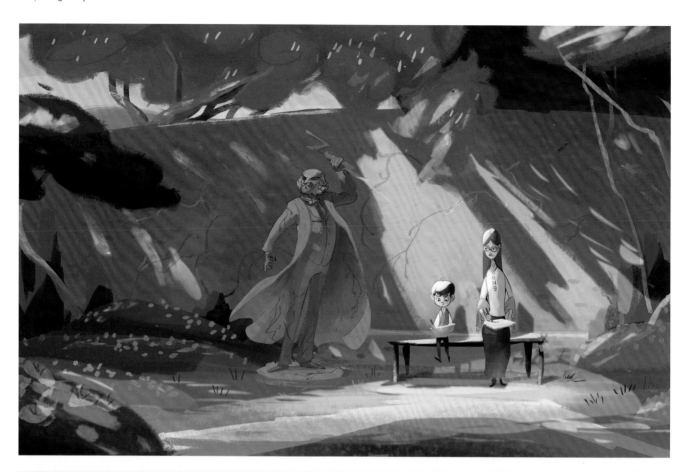

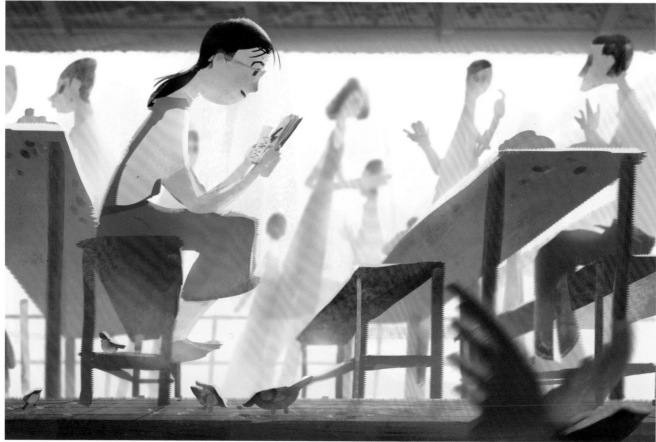

Ang Hui Qing | anghuiqing.com | © Ang Hui Qing

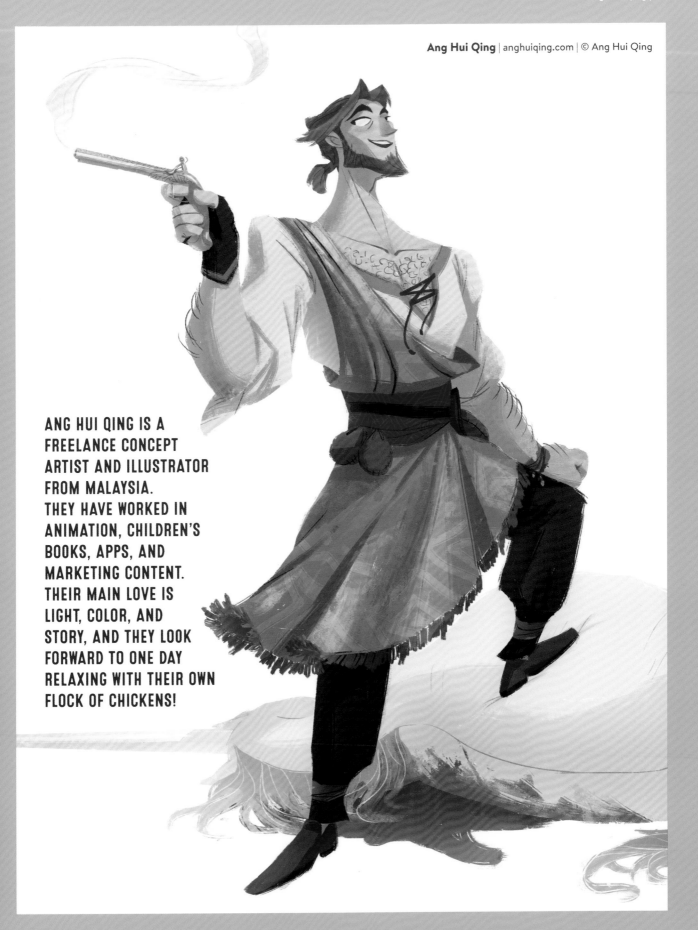

ANG HUI QING IS A FREELANCE CONCEPT ARTIST AND ILLUSTRATOR FROM MALAYSIA. THEY HAVE WORKED IN ANIMATION, CHILDREN'S BOOKS, APPS, AND MARKETING CONTENT. THEIR MAIN LOVE IS LIGHT, COLOR, AND STORY, AND THEY LOOK FORWARD TO ONE DAY RELAXING WITH THEIR OWN FLOCK OF CHICKENS!

ALLISON BERG IS IN
HER SECOND YEAR AT
THE UNIVERSITY OF
VICTORIA, WHERE SHE
IS COMBINING HER
LOVE FOR COMPUTER
SCIENCE AND THE
VISUAL ARTS.
SHE IS PASSIONATE
ABOUT CREATING
CHARACTERS AND
WORLDS THAT PEOPLE
CAN CONNECT WITH,
AND HOPES TO
PURSUE A CAREER IN
CHARACTER DESIGN.

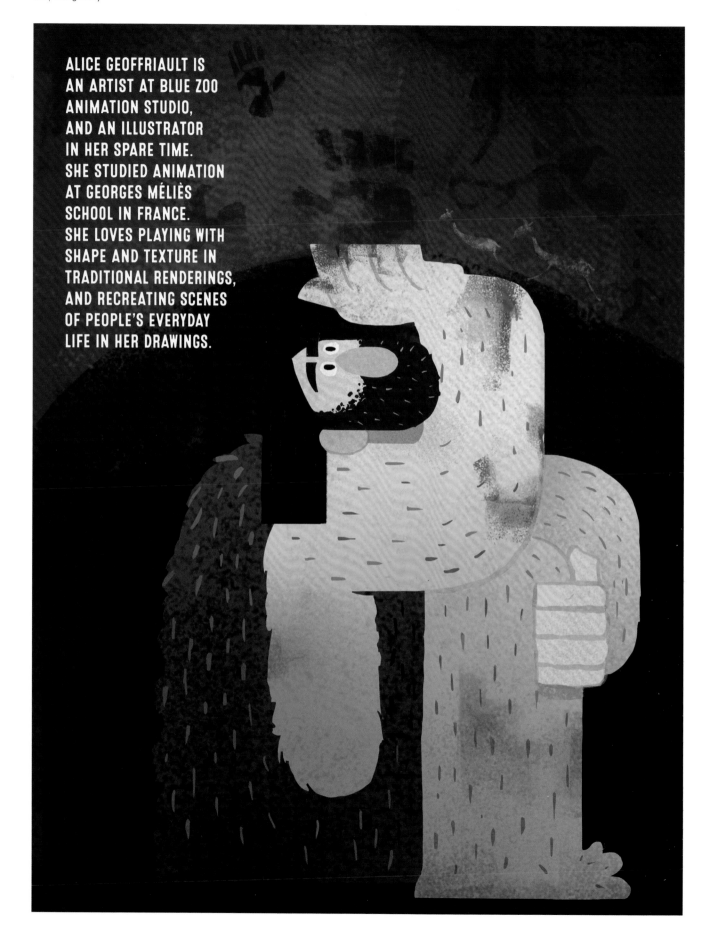

ALICE GEOFFRIAULT IS
AN ARTIST AT BLUE ZOO
ANIMATION STUDIO,
AND AN ILLUSTRATOR
IN HER SPARE TIME.
SHE STUDIED ANIMATION
AT GEORGES MÉLIÈS
SCHOOL IN FRANCE.
SHE LOVES PLAYING WITH
SHAPE AND TEXTURE IN
TRADITIONAL RENDERINGS,
AND RECREATING SCENES
OF PEOPLE'S EVERYDAY
LIFE IN HER DRAWINGS.

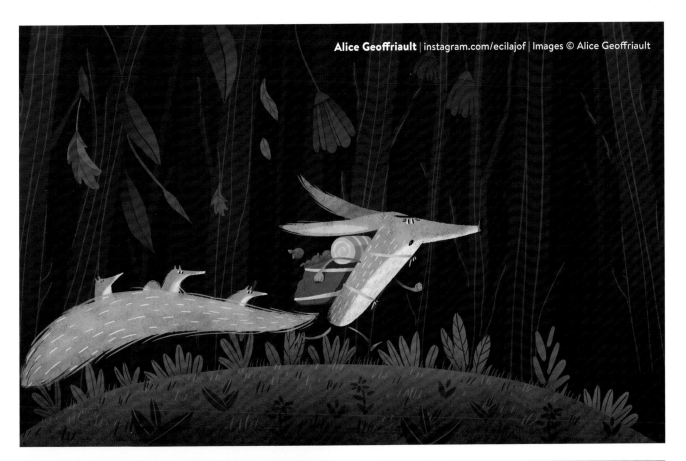

Alice Geoffriault | instagram.com/ecilajof | Images © Alice Geoffriault

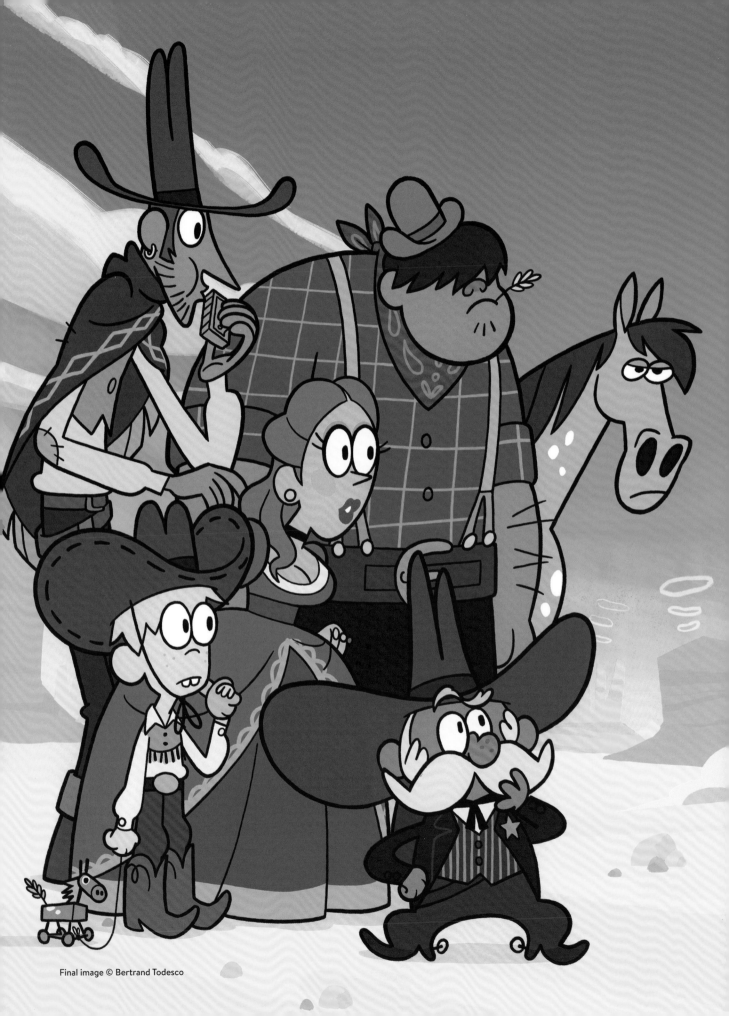

Final image © Bertrand Todesco

CREATING A CAST OF CHARACTERS
BERTRAND TODESCO

In animation, especially for kids, characters within a group must be identifiable at first sight. Who is the hero? Who is the villain? If the design calls for a simple art style, then hairstyles and clothes are so important, especially if the content is episodic and the characters never evolve or change their outfits. Here I'm going to show you how outfits, details, and colors can be used to create a diversified and interesting group of characters. I'm always keen to avoid clichés (even if they can be a good starting point!) and will be showing you how accessories can make each character unique and memorable.

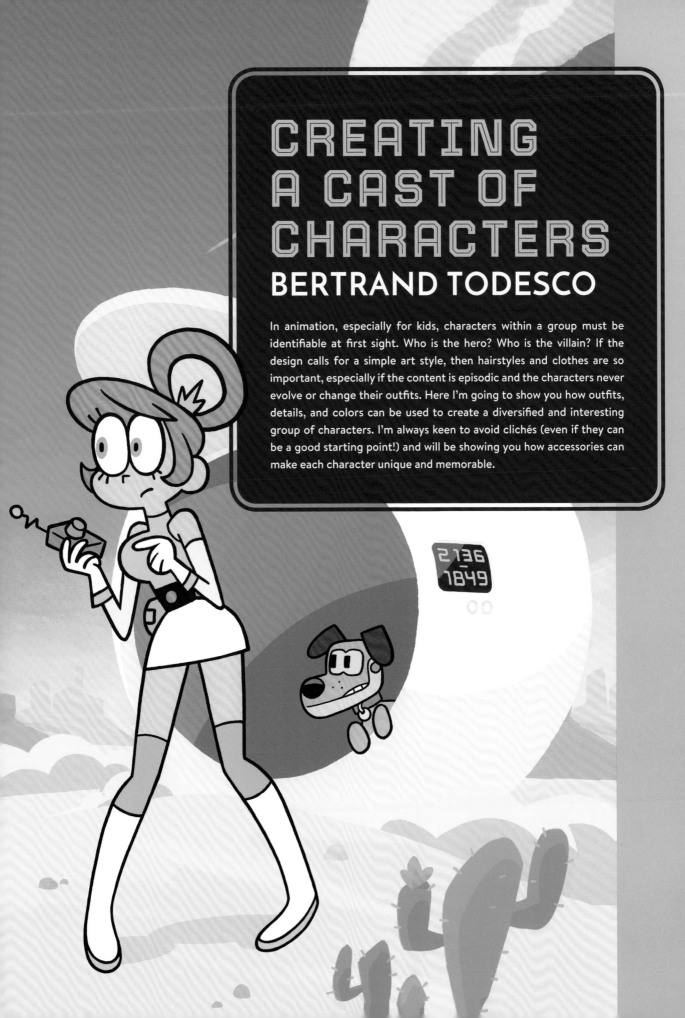

2136 – 1849

TIME TO DRAW!

First of all, I need to select a theme that I can have fun with. How about "time travel"? I can either create a character travelling into the future, or someone from the future heading back in time. I go with the latter option, and next I need to decide what period in history I want to use. My first thought is "cave men," but I think an era with more costumes will give me better options to create a diverse character. So, how about the Wild West? I love the cowboy style! With that decided, I set up a very simple layout, with two groups of characters facing each other. What interests me here is creating a diverse crowd, so I start by simply drawing various shapes, not even knowing yet who each character will be. In these early stages, this simple sketching allows you to begin telling the story – I'm not drawing specific cowboys, I'm just drawing a short guy, a tall guy, a beefy guy, and so on.

This page: Visitors from the future are confronted by a cowboy and their pet

Opposite page: I write a list of words that the theme inspires, then draw them very quickly

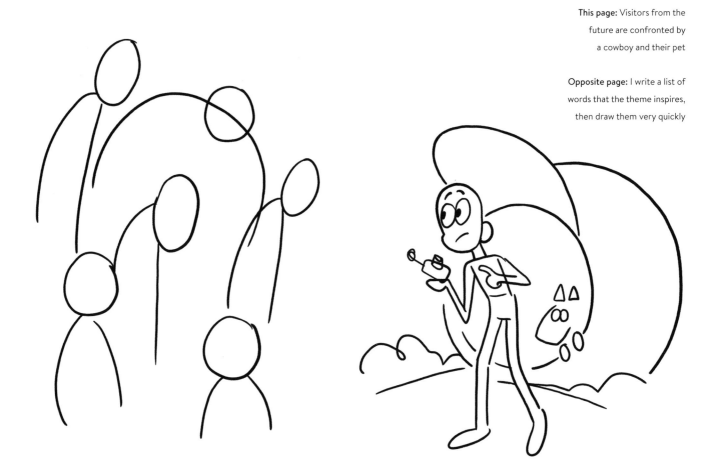

"IN THESE EARLY STAGES, THIS SIMPLE SKETCHING ALLOWS YOU TO BEGIN TELLING THE STORY – I'M NOT DRAWING SPECIFIC COWBOYS, I'M JUST DRAWING A SHORT GUY, A TALL GUY, A BEEFY GUY, AND SO ON"

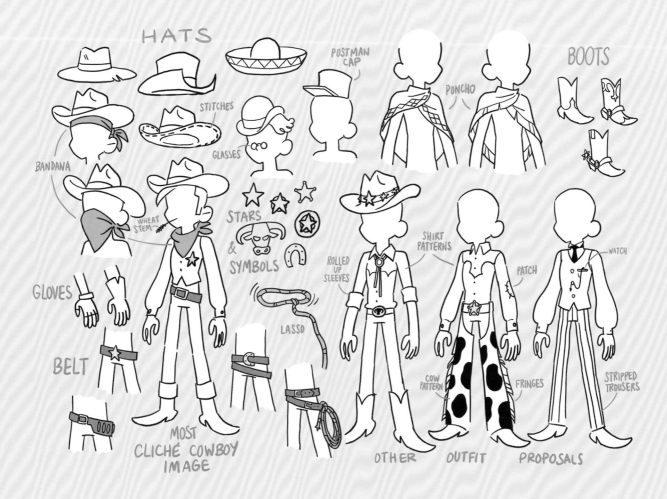

HATS

STITCHES

GLASSES

POSTMAN CAP

PONCHO

BOOTS

BANDANA

WHEAT STEM

STARS & SYMBOLS

SHIRT PATTERNS

ROLLED UP SLEEVES

WATCH

GLOVES

LASSO

PATCH

BELT

MOST CLICHÉ COWBOY IMAGE

COW PATTERN

FRINGES

STRIPPED TROUSERS

OTHER OUTFIT PROPOSALS

WILD WEST RESEARCH

I believe the first step to becoming a good artist is having the ability to observe. Observing things around you is how you analyze, deconstruct, and assimilate shapes, gestures, and colors that you can draw afterward. Obviously, I can't take a trip to the Wild West, but a quick internet search will show me millions of images. Reference images are always important, but especially when you're not familiar with a particular theme – without reference, your work can look too generic. I collect many elements from many sources, so I have a choice of items to select for my characters, avoiding any repetition.

NOT THIS TIME

When researching a particular topic, I always find material that I don't like, for various reasons. In this instance my target audience is kids, so I discard guns, tobacco, or alcohol, even though they are deeply associated with cowboys.

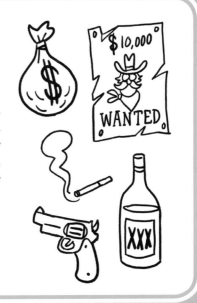

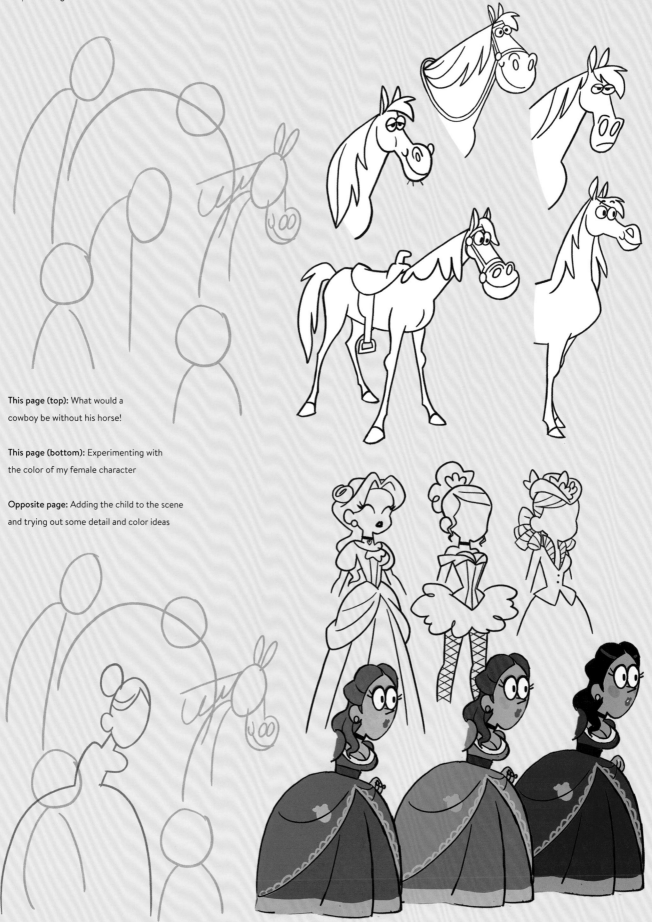

This page (top): What would a cowboy be without his horse!

This page (bottom): Experimenting with the color of my female character

Opposite page: Adding the child to the scene and trying out some detail and color ideas

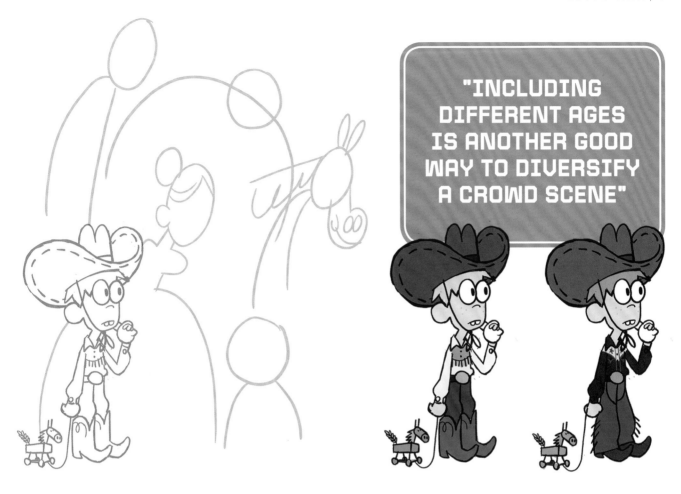

"INCLUDING DIFFERENT AGES IS ANOTHER GOOD WAY TO DIVERSIFY A CROWD SCENE"

HORSING AROUND

I almost forgot to add a horse, the cowboy's faithful companion! I replace one of my human shapes with the shape of a horse. Its silhouette is interesting, so I place it at the edge of the overall shape. There are many different ways to draw a horse; different breeds, colors, hair, and condition. If I draw a horse with perfect braided hair, I will be telling a different story than if I draw a horse whose mane is messy and dirty. Remember, every element of the image adds to the overall narrative.

DIVERSIFYING THE CAST

Of course, cowboys weren't alone in the Wild West, so I decide to add a female character to the crowd. Before even considering drawing a face, I can give the audience information about the character's profession and social standing through their clothes and hairstyle choices. The choice of color can also affect the story the character is telling. I try out three examples of the same character with different shades of skin tone. The dark hair and skin on the right would suggest an Hispanic background,

probably a native of California for generations. The lady on the left is drawn with a paler complexion that suggests she is a colonist, perhaps from the Netherlands, new to the continent at the time of the Gold Rush. It's the same design, but with two very different stories suggested with a simple palette swap.

BILLY THE KID

I continue to elaborate on the story forming on the page, and decide to give the lady a child. Including different ages is another good way to diversify a crowd scene. I have a clear vision from the start of what I want from this character. The little boy is born in America, even though his roots are abroad. He loves the New World, embraces the local fashion, and dreams of becoming a cowboy when he grows up. That's why his clothes are too big and look a little offbeat. I had the idea of including a toy, and decided on a horse to complement the real one. They sit on opposite sides of the shape so work well together.

WHO DREW THE SHERIFF?

So, who's missing from this cowboy jamboree? Why, the sheriff of course! I draw a funny looking guy, short with a huge hat and a huge moustache, because moustaches are always cool! I paint his hair white right away, as I want more diverse ages, with an older character this time. He has the iconic sheriff star, of course. As his body is small and simple, I explore using different patterns to give him some personality in the reduced amount of space. Patterns are the next step in character design for me, after the shape and overall color. They need to reinforce the ideas that I've already started to develop.

A TALL STORY

When drawing a compact group like this, you need to pay attention to the readability of each character. The silhouettes must be easily understandable and without any awkward tangents (places where two or more lines interact in an awkward way). I draw a tall cowboy next, who will be partly hidden by the kid and his mom. I want him to have a different facial expression to the other characters and am unsure what to do with his arms. I remember another common element from the cowboy references – a harmonica! I draw one in and it matches well with his poncho and character. Initially, I imagine him with spurs on his boots, but the sheriff already has these, and it would create an unnecessarily messy section of the picture in the bottom-left corner alongside the kid and his toy.

THE GANG'S ALL HERE

The burly character will have his lower body mostly hidden by other characters, so I need to make his upper body particularly interesting. I save some interesting elements from my references for him – the iconic bandana, a different hat shape, and the stem of wheat in his mouth. This wheat is often used to replace cigarettes in cartoons and comics for kids. Once again focusing on having a diverse set of characters, I hide this character's eyes, in contrast to the wide eyes of the others. His large chest creates a wide, solid block in the image, so I draw a pattern on this area to break the "empty area." How the audience will read the image is important – I don't want any of my gang of cowboys to stand out too much, as the viewer's eye must be drawn to the time traveler first.

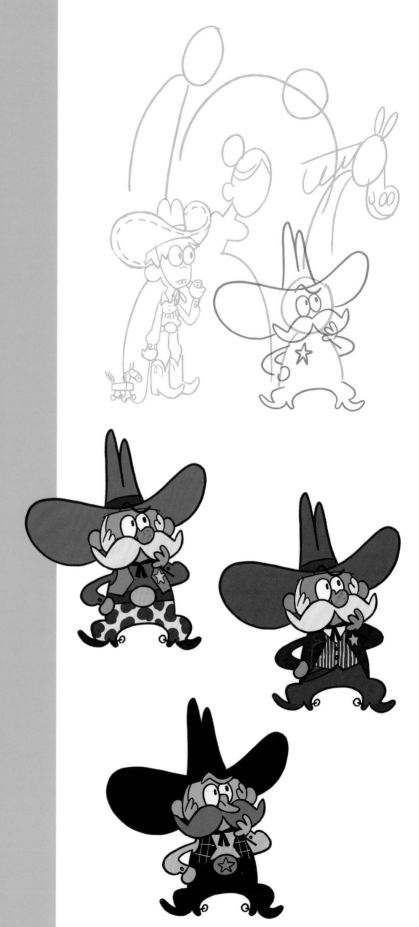

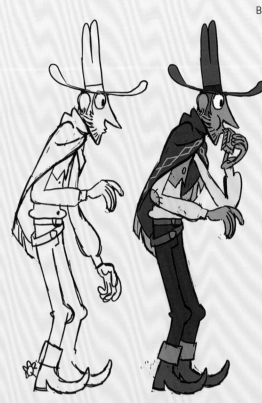

Opposite page: Notice how straight lines or funny patterns change the feeling of the character

This page (top): A cowboy with a three-day beard, a poncho, and a harmonica

This page (bottom): I put all my best ideas into the upper body, as the rest will be hidden

"I DON'T WANT ANY OF MY GANG OF COWBOYS TO STAND OUT TOO MUCH, AS THE VIEWER'S EYE MUST BE DRAWN TO THE TIME TRAVELER FIRST"

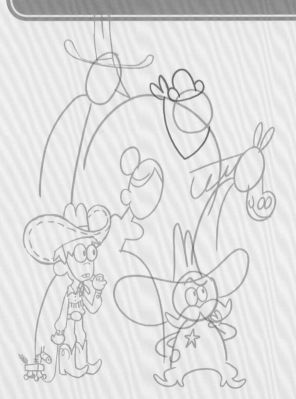

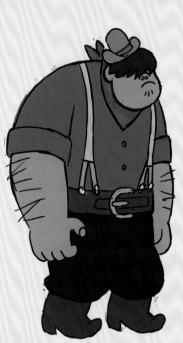

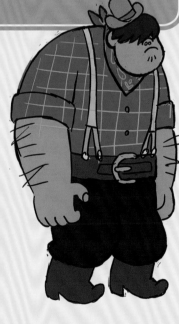

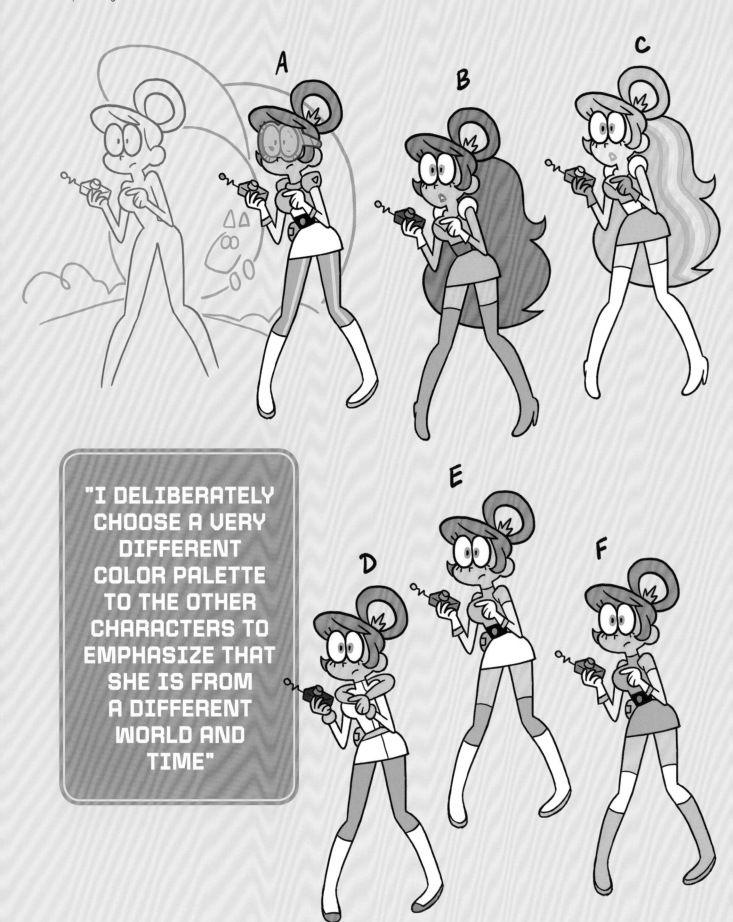

"I DELIBERATELY CHOOSE A VERY DIFFERENT COLOR PALETTE TO THE OTHER CHARACTERS TO EMPHASIZE THAT SHE IS FROM A DIFFERENT WORLD AND TIME"

THE TIME TRAVELLER ARRIVES!

So far, there's only one female character in this illustration, so let's make the time-traveling character a woman and work on her personality and purpose. Maybe she is a soldier from the future, who travels back in time to find an artifact that would change the future (**A**)? Or maybe she's a space princess from a far-off planet, who returns to earth to visit her ancestors (**B** and **C**)? These ideas stray too far from the brief of time travel, though, so I need to think again.

KEEPING IT SIMPLE

I have an idea I'm happy with for my time traveler – she's a teenager who misused the time machine and found herself in an unexpected place and time. Drawing her with flat shoes and no lipstick makes her look younger. I try a more detailed Princess Leia-inspired outfit (**D**) but it looks too complicated. I clear the chest area so the hand can be read easily, and I end up with a simple outfit (**E** and **F**). By toning the outfit down, to something not-too-crazy that could be worn today, I can make the audience more closely identify with her. I deliberately choose a very different color palette to the other characters to emphasize that she is from a different world and time.

A K-9 COMPANION

Who would time travel without their favorite pet? I draw a robot pet as opposed to a real pet, to further confirm the time-traveling story for the audience. Now there's no doubt that this character is from a different time, with her robotic companion and futuristic machinery. I draw a bolt on the dog's head to show he is a robot and use unnatural colors, so there can be no mistaking him for an actual dog.

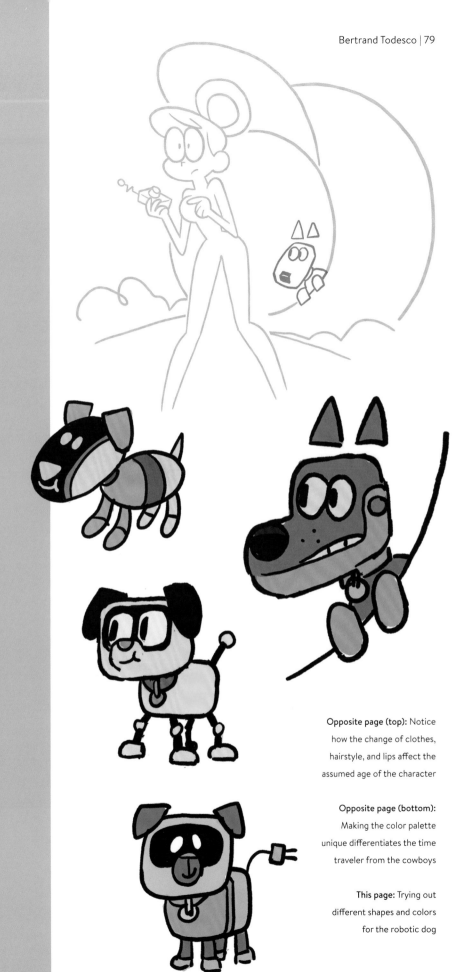

Opposite page (top): Notice how the change of clothes, hairstyle, and lips affect the assumed age of the character

Opposite page (bottom): Making the color palette unique differentiates the time traveler from the cowboys

This page: Trying out different shapes and colors for the robotic dog

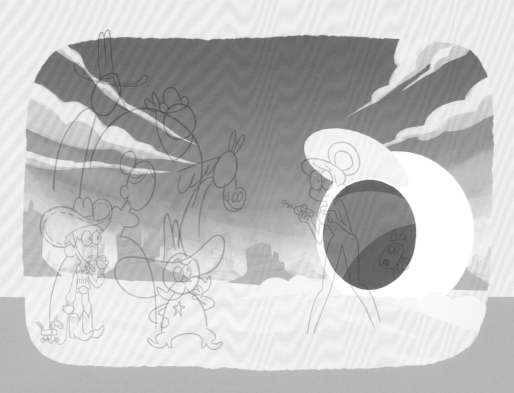

"I ADD CLOUDS TO GIVE DIRECTION AND PERSPECTIVE TO THE PIECE"

THE TONE RANGER

Now I start to draw the background. I use warm tones because the scene takes place in the desert of California, where everything is shades of pink and orange. The time machine is white, pure, and neutral, and the inside is bright blue to contrast the Western background's palette. These bolder colors attract the eye to the right side of the scene first, which is what I want. I add clouds to give direction and perspective to the piece. Although the characters will take up most of the space, it's always good to add some other detail to the background. The flat rocks of the desert are an iconic symbol of the Wild West and, luckily for me, they are also very easy to draw!

TROUBLE AT THE RODEO

Now I place all my characters on the background, again avoiding tangents. The ensemble cast works quite well together, but now that they're in place, I can see a couple of problems. Some characters are bright and others too dark, the beefy guy's head is too small compared to his friend's, and some elements are lost as their color is too similar to another element nearby. There are too many brown tones overall, and the dog's eyes and ears are too dark and attract too much attention. Finally, the time traveler doesn't seem to be looking at the cowboys. So, let's start fixing things!

FINISHING TOUCHES

I set about fixing all the little issues. I brighten up the beefy guy and change his skin tone, so it doesn't merge with the belts and hats. I also remove his hand from behind the lady to avoid any confusing shapes. I add thick, white eyebrows to the sheriff's face so his expression is clearer. I try and vary the shades of blue as best I can, especially for the kid's jeans on top of the woman's dress. I add detail to the horse toy and give the robot dog bright, digital eyes and soften the yellow of his body. For the line work, I use a brush with a textured render, allowing me to draw lines full and loose. These two features give life to the lines and prevent a digitally perfect render look. Finally, I add a screen to the time machine, displaying the traveler's departure and arrival dates for further clarity – she's from the year 2136 and is visiting California during the gold rush in 1849!

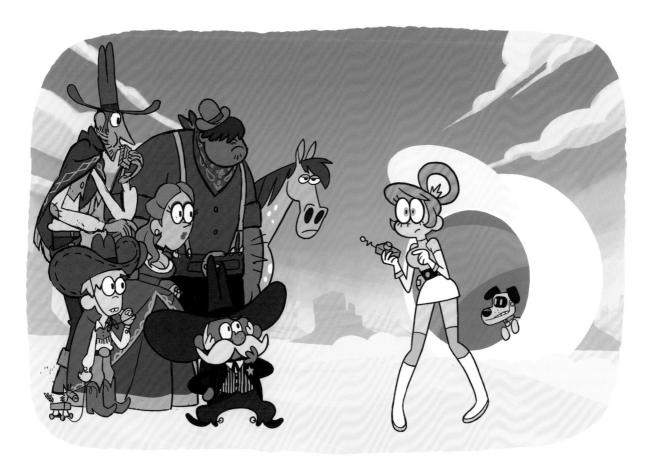

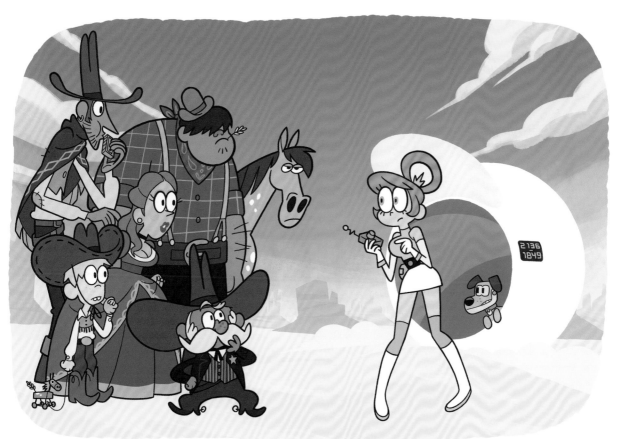

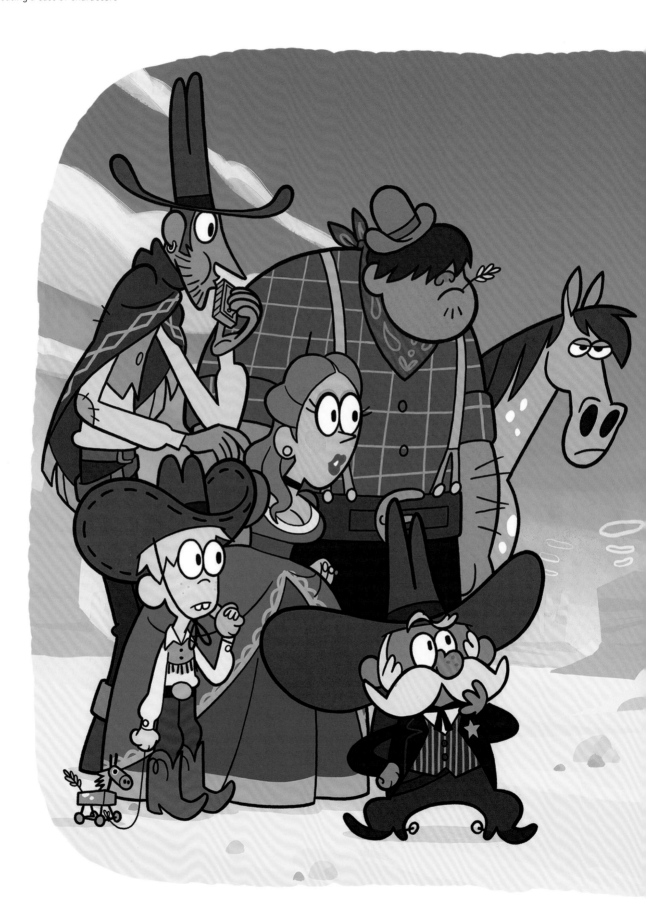

Final image © Bertrand Todesco

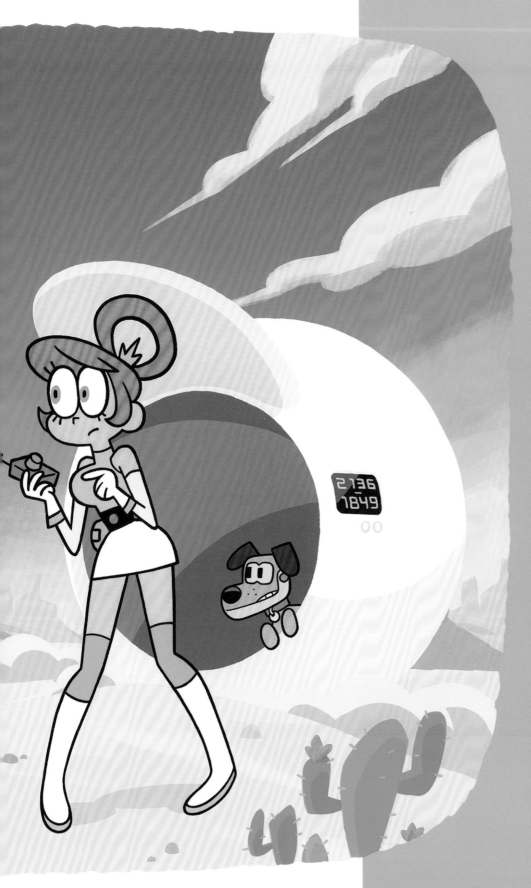

BACK TO THE FUTURE!

I'm happy with the balance of the image, but there are still a few empty areas. I add some rocks to the ground and a cactus in the bottom-right corner. I add shadows to the characters – this is an important part of the process that gives them weight and makes them "sit" on the ground, so they blend in better with the background. Shadows can also help add volume, like on the smoke that surrounds the machine. I add smoke signals rising in the distance to make the landscape feel more alive and as though there are other characters out there in the distance. And with that, my time traveler's journey to the Wild West is complete!

This page: Adding shadows and details fills any empty spaces in the final image

CHARACTERIZE THIS:
REFRIGERATOR, DOG

JORDI LAFABRE

Beautiful designs can be born from combining two, or more, very different concepts. Sometimes the result can be crazy, but sometimes it's as though the combination was always meant to be and was just waiting to be discovered! For this piece the pitch was to combine "dog" and "refrigerator." I imagined a vendor at a stadium, walking around selling cold drinks to sports fans – but what if the vendor was a dog?

THE CORE CONCEPTS

To begin, it's a fun and useful creative activity to consider what the brief is literally saying, and then think of the opposite. So, in this case I thought of a cool dog, and then a hot dog, and from there I started to think about sausage dogs...

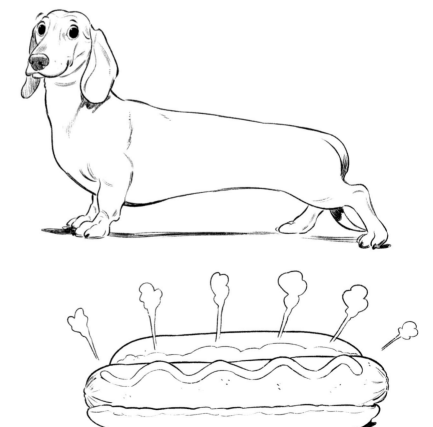

THE FIRST SKETCHES

Now that I have a concept, I make several sketches and see what happens, working through different designs and exaggerating features. My designs can go from very cartoony to realistic and back again. At this stage I'm trying to get a feel for what style fits the brief.

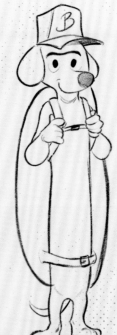
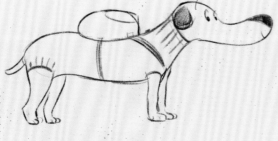
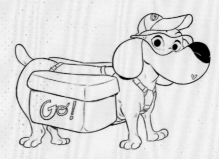

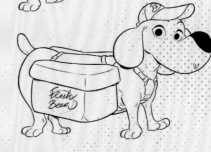
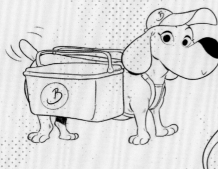
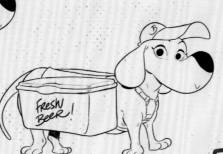
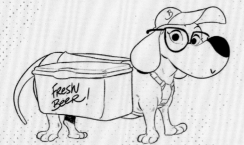

EXPLORATION AND PROPS

Now I have the direction I want, it's time to work on props for the character and start to add little details. A solid amount of research at this stage can provide even a cartoony design with a realistic base, which can have a huge impact on your design.

THE FINAL DRAWING

I chose this version as my final drawing as it has a good balance of clear shapes and enough information for the design to explain itself without any extra information. Ideally, a good character design is charismatic enough that it stands out in the audience's mind from first sight.

PERSONALITY AND EXPRESSIONS

I consider not only the personality of the characters I create, but also how that meshes with their role. In this case, I go with a smile – my vendor dog should be polite and reasonable, even if her customers are annoying!

THE ADVANTAGES OF DIGITAL DESIGN

For this design, I used Procreate on an iPad Pro throughout the entire process, from the rough concepts to the final color design. While I love to draw with pencil and paper, I find that when it comes to character design, working digitally makes it easier to work through a lot of different options for my design, without having to draw everything from scratch several times over.

THE FINAL COLOR PIECE

Colors are crucial. Here, the "hot dog" reference comes across loud and clear, with the mustard color on the uniform complementing the dark browns of the dog herself. I use flat and simple colors to help give the character a simple, defined look, staying away from any hair textures or plastic reflections. And with that, I'm finished. Meet Loretta – a dog from a Latino family who works as a stadium vendor. Two ice cold sodas, please!

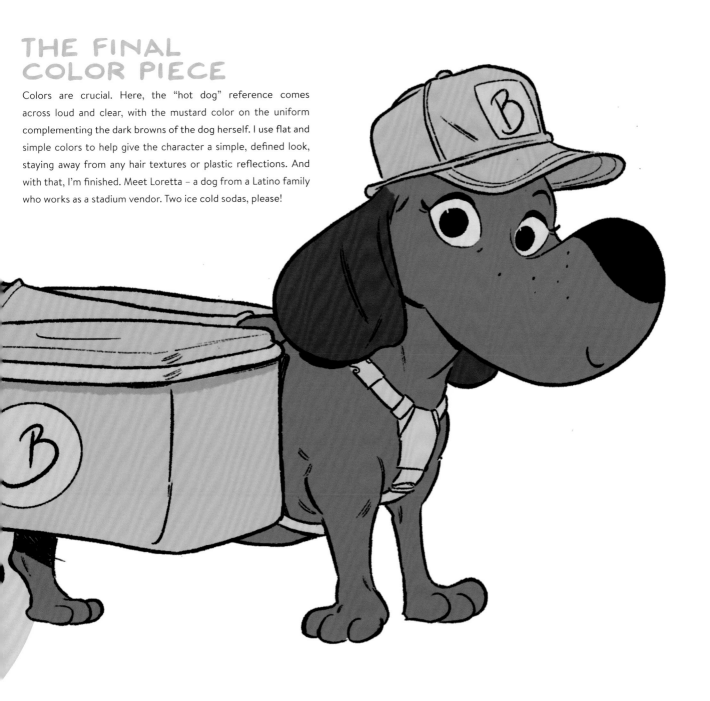

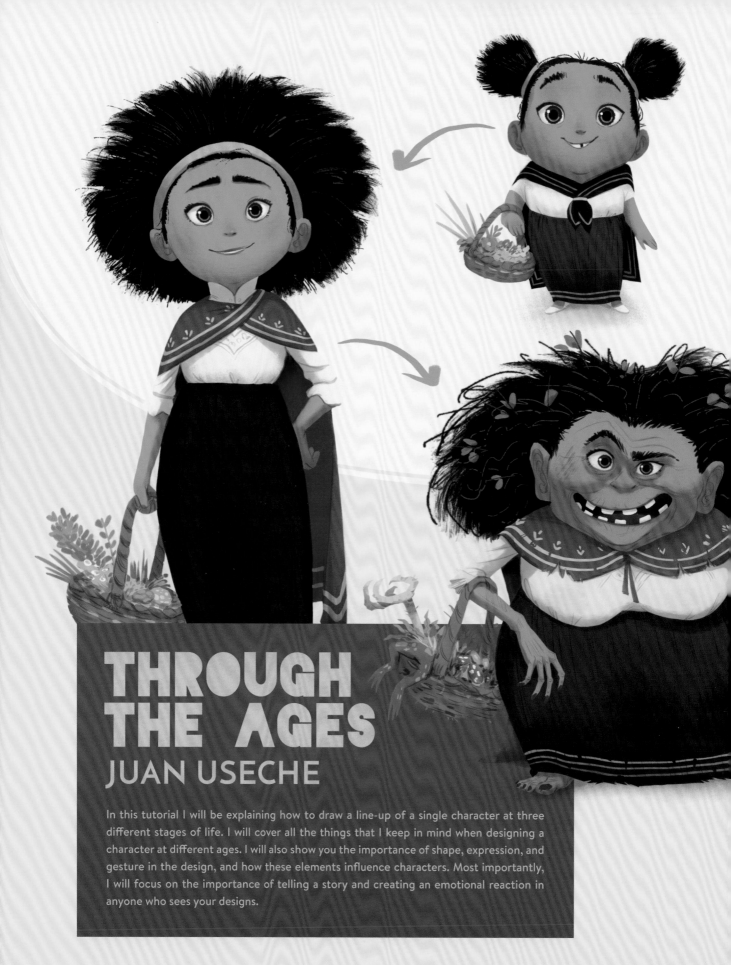

THROUGH THE AGES

JUAN USECHE

In this tutorial I will be explaining how to draw a line-up of a single character at three different stages of life. I will cover all the things that I keep in mind when designing a character at different ages. I will also show you the importance of shape, expression, and gesture in the design, and how these elements influence characters. Most importantly, I will focus on the importance of telling a story and creating an emotional reaction in anyone who sees your designs.

MAPPING THE MIND

Sometimes, you might get a very detailed brief from a client that you simply need to follow and complete. But when it comes to finding an idea for your very own character, it can take a lot more effort to settle on what to do. The first step is to organize your thoughts and ideas into a mind-map, to make things less overwhelming. I like to start with the aspects I am certain of – in this case that I'm creating a character in three different stages of her life – and from there, I add words associated with the ageing process, along with stereotypical personality traits for each age.

This page: Creating mind-maps is a great way to come up with ideas quickly

FLOWERS

METAMORPHOSIS

NATURE

ENTROPY

EVOLUTION

SEASONS

PASSING OF TIME

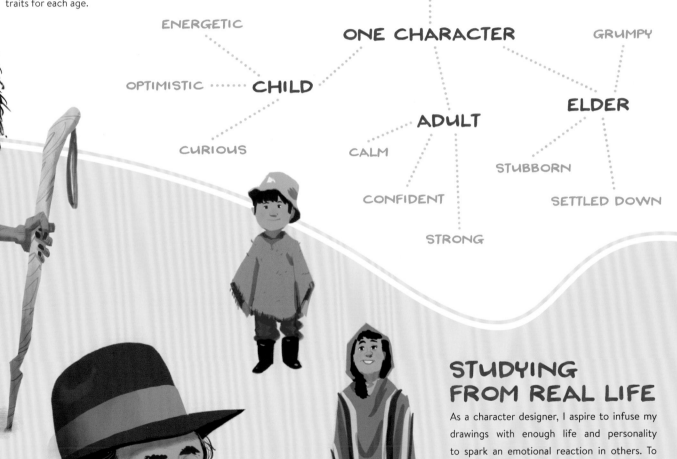

ENERGETIC

ONE CHARACTER

GRUMPY

OPTIMISTIC · · · · · CHILD

ELDER

ADULT

CURIOUS

CALM

STUBBORN

CONFIDENT

SETTLED DOWN

STRONG

STUDYING FROM REAL LIFE

As a character designer, I aspire to infuse my drawings with enough life and personality to spark an emotional reaction in others. To me, one of the best ways to achieve that is by studying real-life people. Especially when a project involves representing a particular group of people, I try to learn and explore as much as possible about the culture, customs, and behaviors of such groups. These are some studies I did of Colombian townspeople.

SOMETHING BORROWED, SOMETHING NEW

Since this tutorial is focused on the passing of time, I want to create a simple story for my character as she ages. I imagine she lives somewhere in Colombia in the 1800s. I also want my character and her story to have a subtle fantasy element – maybe she is some kind of witch who lives out in the wilderness. I'm aiming for a healthy mix of something I know, and something completely different. Therefore, I want to bring stereotypical ideas into the design and then mix them with my own personal style. At this early stage, research and study is a fundamental part of the process.

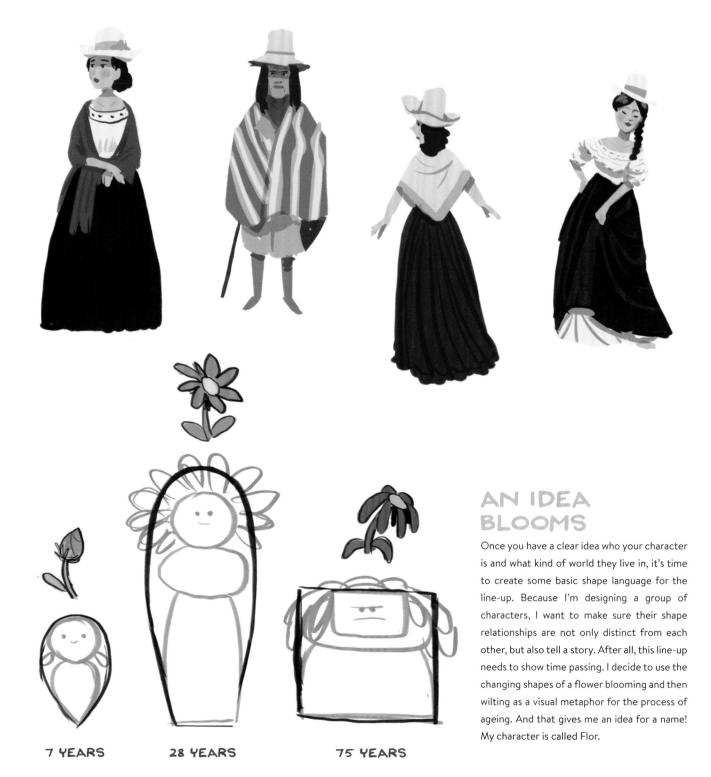

7 YEARS 28 YEARS 75 YEARS

AN IDEA BLOOMS

Once you have a clear idea who your character is and what kind of world they live in, it's time to create some basic shape language for the line-up. Because I'm designing a group of characters, I want to make sure their shape relationships are not only distinct from each other, but also tell a story. After all, this line-up needs to show time passing. I decide to use the changing shapes of a flower blooming and then wilting as a visual metaphor for the process of ageing. And that gives me an idea for a name! My character is called Flor.

FLOR IS BORN!

For Flor as a child, I want to extend the floral metaphor by using a drop shape, like a flower bud, as her main shape. When exaggerating small children's proportions, the head becomes almost a third of their entire body, which has the effect of making their legs and arms look very small. An inverted drop shape is very representative of a little child because of the similar proportions, in the way that the top is round and big, while the bottom becomes smaller and pointier. I sketch some thumbnails in which the drop shape is prominent, even in Flor's haircut and eye shape. For her clothes, I use my previous sketches of 1800s outfits as reference.

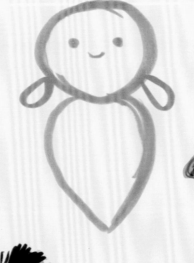

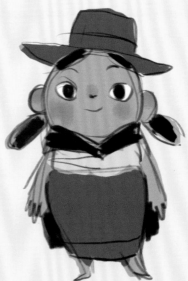

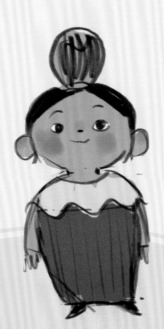

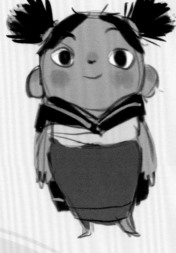

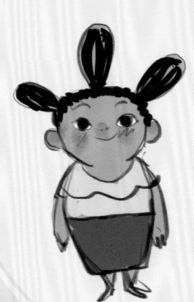

Opposite page (top): Studies of traditional clothing in Colombia in the early 1800s

Opposite page (bottom): Start with the black primary shapes and then draw more detailed secondary shapes, shown here in red

This page: Flor as a child – she is a healing witch in training

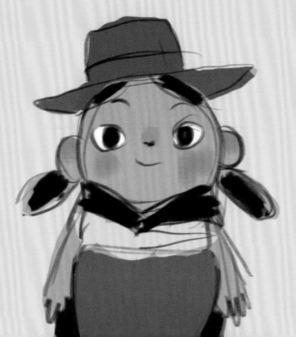

HAT OR NO HAT?

My research into 1800s Colombian dress revealed it was usual to wear a hat that complemented the dress. I like these type of hats a lot, but in the end it would have detracted from Flor's hair, which I thought was a lot more unique and expressive, and an essential part of her personality and story.

GROWING PAINS

Adult Flor is a more confident and well-established person, a knowledgeable and proud healer witch. However, a hint of her inner child is still shining through. To show this, I decide to keep the drop shape from the first sketch and transform it to fit her age. I try stretching the shape and giving it a wider base to represent her being a more stable and responsible person. I imagine her hair as the petals of a flower and want to make them a significant part of the finished design. Her hair represents a stage in her life where she feels powerful and liberated.

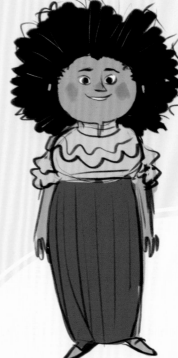

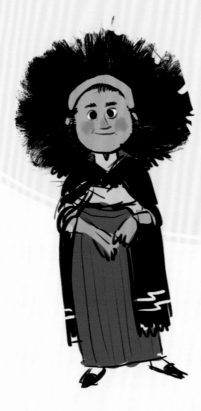

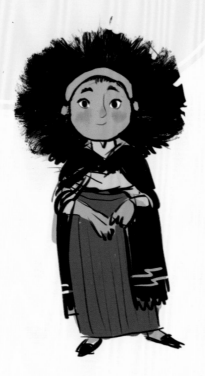

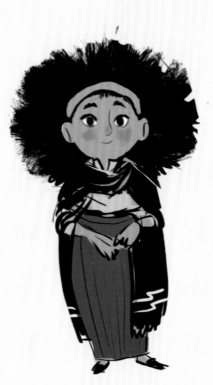

This page: Thumbnailing is a great stage to try out different proportions and facial features

Opposite page: Elderly Flor has completely changed her practices and personality

INTO THE WOODS

For Flor's elderly design, I want to give her a more radical transformation. I want the viewer to be asking, "What could have happened to her?!" I'm trying to tell a story through just three images, so with limited space, every little detail counts. I change her body shape from round and light to something more square and heavy. At this stage, I associate her with a withered flower – her hair still represents petals, only now it droops down and is uncared for. I imagine some life-changing event happened in middle-age that forced her to go and live a secluded life in the wilderness.

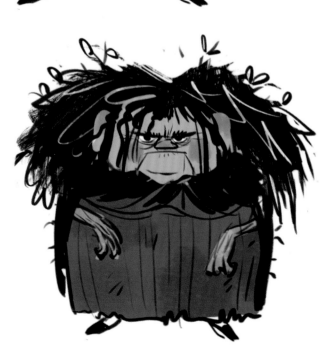

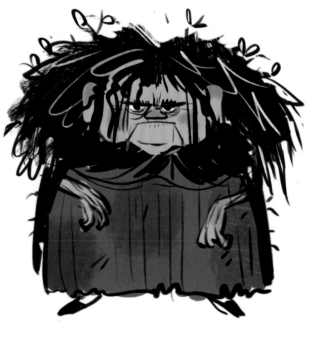

"I'M TRYING TO TELL A STORY THROUGH JUST THREE IMAGES, SO WITH LIMITED SPACE, EVERY LITTLE DETAIL COUNTS"

THE LIFE OF FLOR

Once I have thumbnails for all three of Flor's life stages, my next step is to select the most successful sketches and put them together. At this point I always ask myself, "What makes this particular sketch more successful than the others?" The answer is often a mix of intuition and evaluating how much the design communicates my intentions, or in this case, shows my story. I choose the three sketches that appeal most to me and are the most efficient. Efficiency means they are compelling but also straightforward designs that best convey my initial intentions. Remember, simplicity always communicates better with the audience.

HIGHS AND LOWS

I'm happy with my three thumbnails, but there is still room for improvement. I imagine Flora in a CG animated production, but every design will not necessarily work when in motion. I now need to make sure my characters can perform, move around, and express themselves in 3D space. For this, I pose the characters in different story moments. This is a crucial step for establishing an emotional connection with whoever looks at your designs. I sketch some gestures for Flor's highs and lows as a little girl, and another frontal pose.

"I NOW NEED TO MAKE SURE MY CHARACTERS CAN PERFORM, MOVE AROUND, AND EXPRESS THEMSELVES IN 3D SPACE"

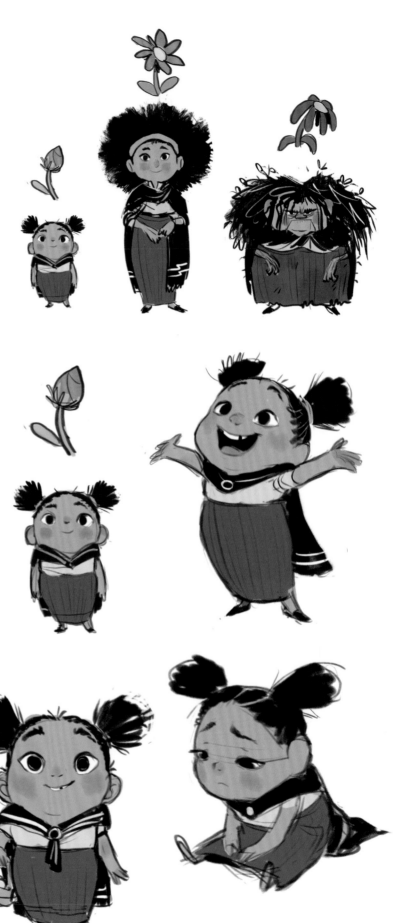

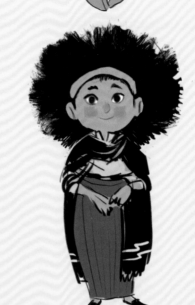

CHANGING FACES

The sketches of Flor as a girl are a great foundation for me to continue developing her as an adult. I can now decide what specific features of her design will remain throughout all her stages of life, and what will change. For example, I want the head shape to change significantly throughout her life, but I want her eye size and distance to remain relatively constant. It's all about making sure the character is consistent through the three different ages, without sacrificing her capacity to emote and gesture. I want every age to be at once recognizable and unique!

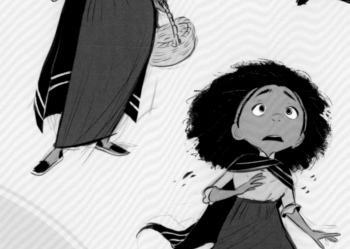

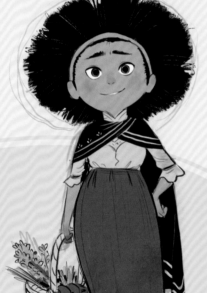

Opposite page (top): I put my thumbnails alongside one another to check if the design remains consistent

Opposite page (bottom): Sketching Flor with different emotions will lead to a better final design

This page: At this age Flor's emotions are much stronger, as she is exposed to more extreme situations

DRAWING GESTURES

Drawing gestures is a big part of a character designer's job, because they're the best way to persuade others that your design can support the emotional weight and complexity of a story. The more communicative and expressive your character's gestures are, the more compelling your design will be. Drawing your character gestures from a completely frontal angle may take away some of the energy and volume that creates the illusion of life. Instead, opt to sketch gestures from side angles – this will help others imagine your character in a 3D space.

RELEASE THE INNER CHILD

Since the earliest sketches, I've wanted to avoid duplicating the same design structure for the different ages, where adding wrinkles and other small changes would be the only difference in each look. Every design needs to stand out on its own while still being recognizably the same person in each image. In her old age, Flor has gone through many difficulties, and I want the design to present questions about what could have happened to her. I sketch poses that show emotions that are different to anything she felt in her earlier years, but then also draw her upset and sitting as she did as a little girl.

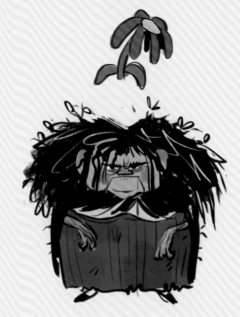

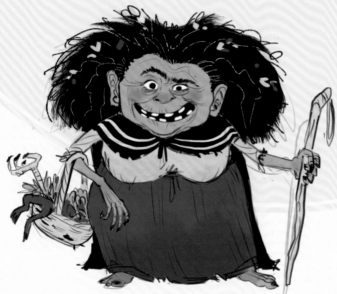

"EVERY DESIGN NEEDS TO STAND OUT ON ITS OWN WHILE STILL BEING RECOGNIZABLY THE SAME PERSON IN EACH IMAGE"

WHAT'S IN THE BASKET?

As I did in step 7, I now gather all my designs together and check for consistency and clarity, selecting the poses I will use for the final rendered line-up. I need to make sure they work individually and as part of a sequence, and that their silhouettes are clear and recognizable. I check if the shapes are still consistent with my original idea and make some small adjustments to the facial features, adding more detail. I give Flor a foraging basket, which will let the audience know more about the things she uses to cook or make healing potions. Adding a single prop can make the story being told so much richer.

Opposite page: Flor is now a masterly old witch – her moral compass is a little damaged, but deep down she's the same person she always was

This page: Even though the silhouettes have changed, I keep the same basic shapes

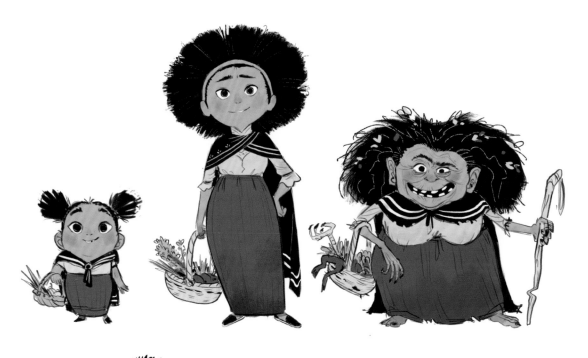

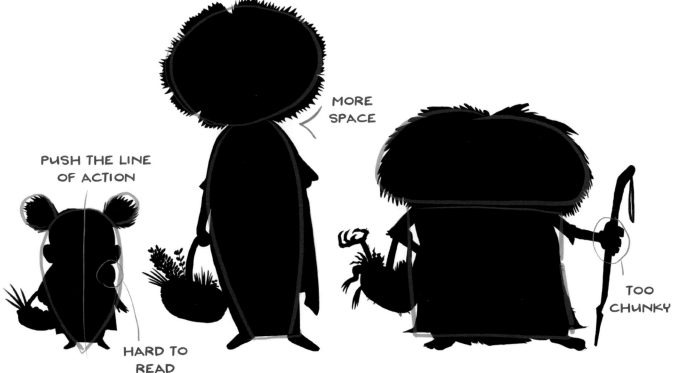

PUSH THE LINE OF ACTION

MORE SPACE

HARD TO READ

TOO CHUNKY

IT'S COLORING TIME

Choosing colors is one of my favorite steps in the design process. I usually have an intuitive approach to the process, picking color palettes based mostly on personal appeal. But in this case, I'm still using the traditional Colombian clothing as a reference, so I want to keep to similar color arrangements. I try several different palettes before going back to the one I chose originally. At this stage, I'm just blocking the base colors very roughly and quickly – after all, there is still a color-testing phase to come.

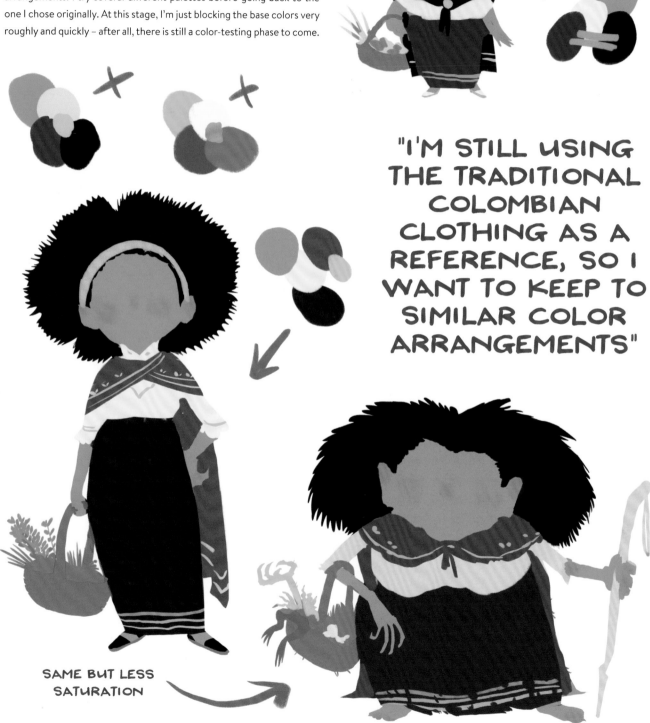

"I'M STILL USING THE TRADITIONAL COLOMBIAN CLOTHING AS A REFERENCE, SO I WANT TO KEEP TO SIMILAR COLOR ARRANGEMENTS"

SAME BUT LESS SATURATION

Opposite page: Blocking out the base colors

This page: I polish the base colors and add lines for detail

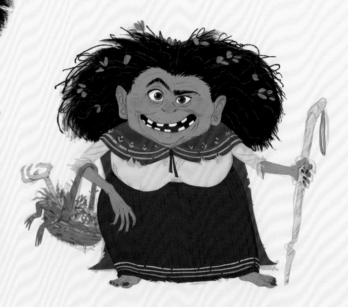

THE FINER DETAILS

Now it's time to start adding the finer details. This is when everything starts to become more alive and expressive, and when it's easy to spot if certain aspects of the design are not entirely working. For example, there are some minor issues with the silhouettes that are affecting the clarity of the drawings. I also decide on what will be in Flor's basket and the details on her face. I don't want to overwhelm the design with detail, so I make sure to keep only elements that are communicating the narrative. For instance, I show the passing of time subtly in Flor's clothing by introducing damage and tears as time passes.

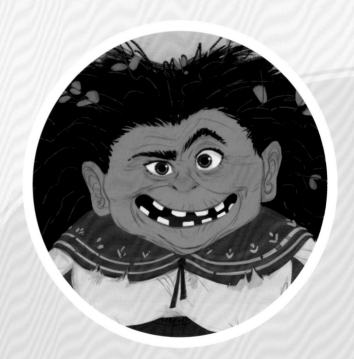

MIRROR YOUR CANVAS!

Sometimes, something in my character's face feels a little off, and I can't put my finger on what it is. In most cases it will be a matter of imbalance in elements of my design. If this happens to you, try flipping or mirroring your canvas. This helps you spot these issues and gives you a better idea of how to fix them. You'll be surprised just how different your design looks when it's mirrored! If the drawing works when flipped, it will have a much better chance of being successful the right way round.

Opposite page: Every time I add a new element, I make sure it's helping to communicate the story

This page: The finishing touches, adding shadows, and correcting color contrast

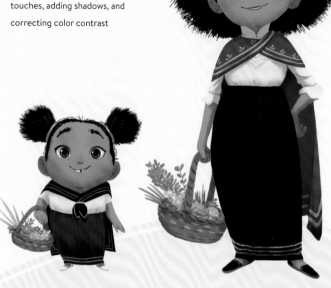
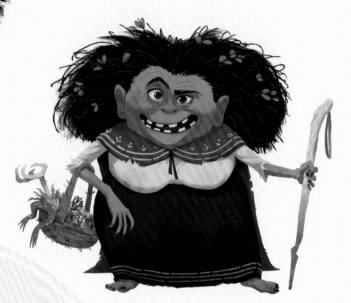

DIGGING IN THE DIRT

I would usually avoid rendering too much, but since I'm planning for these characters to be modelled in 3D, I want to give them the necessary extra volume to help the 3D artists interpret my designs as sculptures. I like to keep my shading method very simple – I use a single color layer, in Multiply mode at 30–40% opacity, for all my shadows. This helps to keep the look consistent and manageable. I also add some more subtle textures to further communicate the story, like dirt on elderly Flor's body, as she now lives in the wilderness.

A WITCH FOR ALL SEASONS

With the designs almost finished, I now go back over the drawings one last time and make sure the color contrast is working correctly, that the silhouettes are clear, and that the character's expressions are compelling and communicative. I decide I want the colors to pop a bit more, so delicately increase the contrast and saturation in certain areas. Finally, I add a soft shadow under the characters – this adds weight and makes them feel more grounded and volumetric. And that's it! Flor's journey is complete and I'm ready to prepare my file to share on social media, add to my portfolio, or send to the client.

"I DECIDE I WANT THE COLORS TO POP A BIT MORE, SO DELICATELY INCREASE THE CONTRAST AND SATURATION IN CERTAIN AREAS"

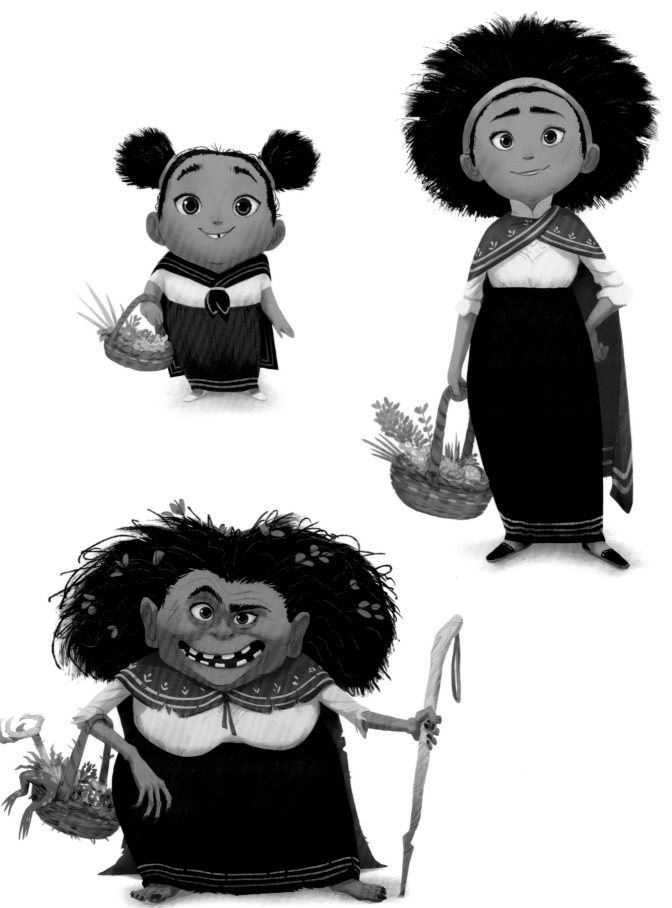

Final image © Juan Useche

CONTRIBUTORS

SANDRO CLEUZO

Character Animator and
Character Designer, Warner Bros.
inspectorcleuzo.blogspot.com

Sandro is a Brazilian born artist and
self-taught animator and character
designer. His work for films includes
Anastasia, *Fantasia 2000*, and *Klaus*.

MARTA GARCÍA NAVARRO

Freelance Illustrator and
Character Designer
www.marganamgn.com

Marta is a Spanish illustrator and
character designer. Her recent work
includes illustrating two books and
concept characters for a videogame.

ILSE HARTING

Freelance Illustrator
and Concept Artist
www.ilseharting.net

Ilse is an illustrator and concept
artist based in the Netherlands, who
mostly creates character designs and
illustrations for the gaming industry.

JORDI LAFEBRE

Freelance
jordilafebre.format.com

Jordi is an award-winning artist
and author with over twenty years
experience in the industry. He loves
character design and graphic novels.

PANIMATION

Founders: Bee Grandinetti,
Linn Fritz, and Hedvig Ahlberg
www.panimation.tv

Panimation is a multi-platform
community for women, trans, and
non-binary people working with
animation and motion graphics.

HYUN SONG

Character Designer, Million Volt
instagram.com/hyunsong.we

Hyun is a character designer and
illustrator with nine years experience
in the industry, working with Netflix,
Dreamworks TV, and Warner Bros.

BERTRAND TODESCO

Character Designer, Titmouse Inc.
juanuseche.art

Born in France, Bertrand graduated
from Supinfocom, and created the
main characters for five TV shows. He
now lives and works in Los Angeles.

MAX ULICHNEY

President, Brushmancer
of MaxPacks, Inc.
www.maxulichney.com

Max Ulichney is an illustrator and
animation art director based in Los
Angeles whose clients include Netflix,
Marvel, and Warner Bros.

JUAN USECHE

Freelance Character Designer
and Visual Development Artist
juanuseche.art

Juan is a Colombian artist based in
Berlin, with a passion for cute and
imaginary things. He currently works
as a freelance artist for various clients.

TATTOOS
BY LORENZO ETHERINGTON

AS YOU BEGIN TO APPLY **ACTUAL DESIGNS**, KEEP AN EYE ON THE **VISUAL BALANCE** OF YOUR TATTOOS – AIM FOR A **FINE LEVEL OF DETAIL**, BUT WITH **CLEARLY DEFINED** AREAS OF **COLOUR** AND **SHAPE!**

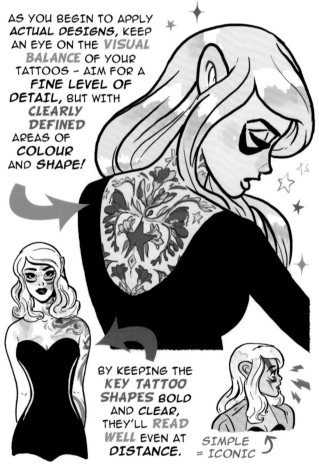

BY KEEPING THE **KEY TATTOO SHAPES** BOLD AND **CLEAR**, THEY'LL **READ WELL** EVEN AT **DISTANCE.**

SIMPLE = ICONIC

SPIRAL DOWN

REAL LIFE TATTOOS ARE OFTEN BUILT UP **OVER TIME**, AND CAN END UP FEELING A BIT **MUDDLED**, BUT HERE WE GET TO CREATE A SINGLE, **HARMONIOUS PIECE** ACROSS THE **ENTIRE CHARACTER.**

ASYMMETRY!

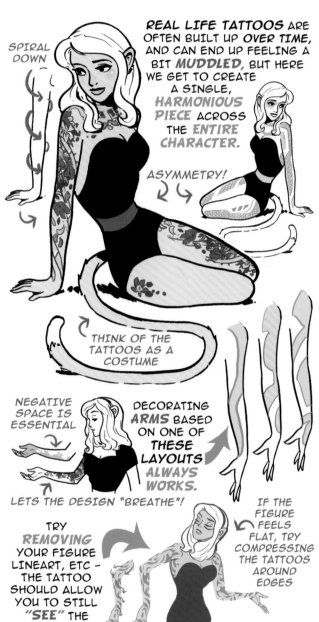

THINK OF THE TATTOOS AS A COSTUME

NEGATIVE SPACE IS ESSENTIAL

LETS THE DESIGN "BREATHE"!

DECORATING **ARMS** BASED ON ONE OF **THESE LAYOUTS** ALWAYS **WORKS.**

TRY **REMOVING** YOUR FIGURE LINEART, ETC – THE TATTOO SHOULD ALLOW YOU TO STILL **"SEE"** THE FORM.

IF THE FIGURE FEELS FLAT, TRY COMPRESSING THE TATTOOS AROUND EDGES